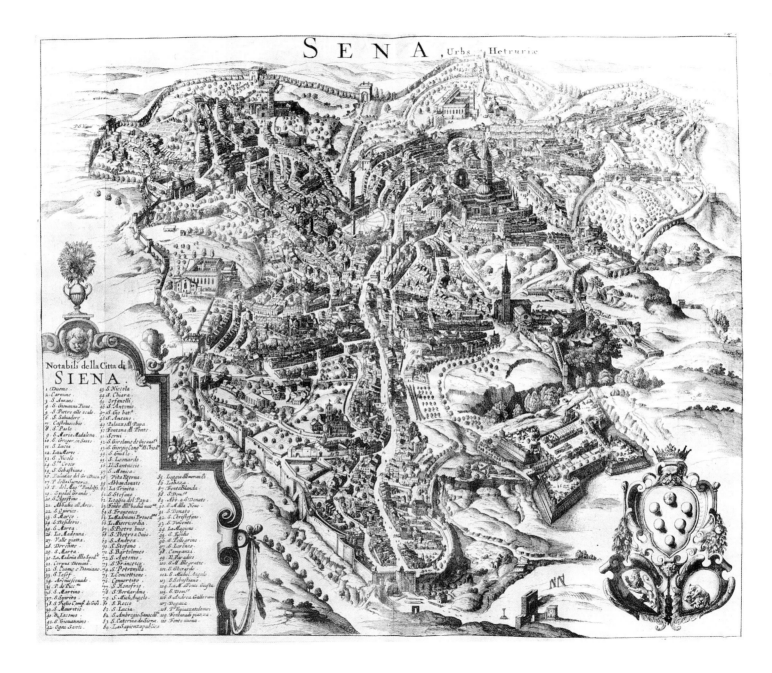

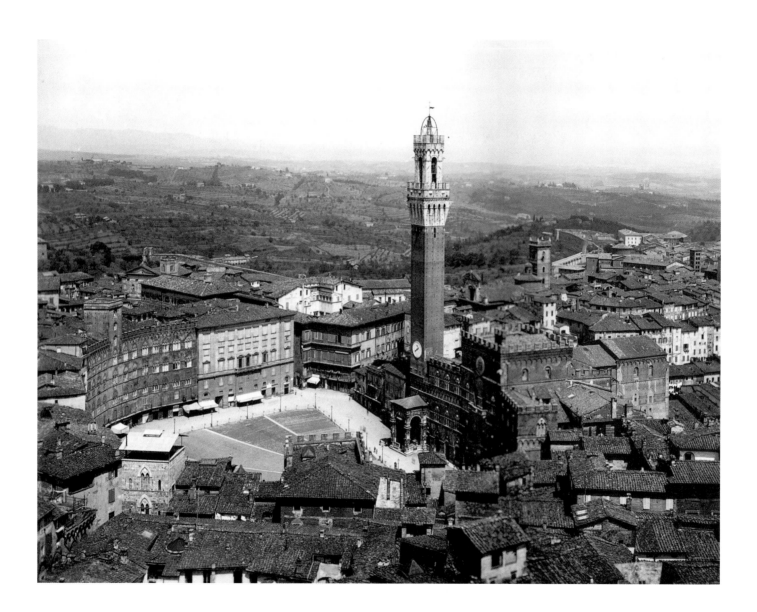

Ambrogio Lorenzetti
The Palazzo Pubblico, Siena

Randolph Starn

GEORGE BRAZILLER NEW YORK

Published in 1994 by George Braziller, Inc.

Texts copyright © George Braziller, Inc.

Illustrations (except where noted) copyright © Scala/Art Resource, New York

For information, please address the publisher:

George Braziller, Inc.

60 Madison Avenue

New York, New York 10010

Library of Congress Cataloging-in-Publication Data:
Starn, Randolph.
 Ambrogio Lorenzetti: the Palazzo pubblico,
Siena/Randolph Starn.
 p. cm.—(The Great Fresco Cycles of the Renaissance)
 Includes bibliographical references.
 ISBN 0-8076-1313-4
 1. Lorenzetti, Ambrogio, ca. 1295–1348—Criticism and
interpretation. 2. Politics in art. 3. Mural painting and
decoration, Renaissance—Italy—Siena. 4. Palazzo pubblico (Siena,
Italy). I. Lorenzetti, Ambrogio, ca. 1295–1348.
II. Title. III. Title: Palazzo pubblico, Siena. IV. Series.
ND623.L75S72 1994 93–21670
759.5–dc20 CIP

Half-title page: Map of Siena, Orlando Malavolti,
Dell' historia di Siena (Venice, 1599).
Opposite title page: Piazza del Campo, Siena.

Designed by Lundquist Design, New York

Printed by Arti Grafiche Motta, Arese, Italy

CONTENTS

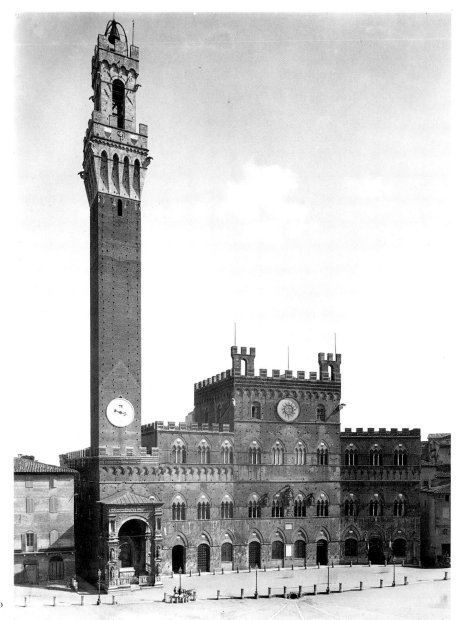

Figure 1: Palazzo
Pubblico, Siena.

PREFACE

Plato and a long line of philosophers agree in banishing artists from utopia. They do so with good reason of course, though not necessarily for the reason most often put forward—that artists create, at best, pale imitations of truth and beauty. The philosophers' problem, one suspects, is that the images of art can be so powerful and persuasive.

In Italy the *bella figura*, the stagily perfect impression, has compensated for a multitude of imperfect realities, to the point of becoming on its own a kind of reality. To the French philosopher Descartes's "I think therefore I am," the Italians have often replied, "We are seen, therefore we are." This being the case, the priests and the politicians have never been far behind artists, or one another, in cultivating the power of the image. The early twentieth-century Italian avant-garde had a point in wanting to begin their revolution by destroying the art museums.

Historically, no art form is more Italian, more public, or more embedded in considerations of power than fresco. The facts are overwhelmingly clear, the explanations still debatable. Between 1300 and 1600, the Golden Age of fresco painting, literally thousands of frescoes were painted in churches and town halls, castles and palaces, open-air chapels and civic arcades all over the Italian peninsula. (Venice, already a man-made marvel and an ecological disaster, was an exception because fresco could not tolerate the dampness of the Adriatic lagoon.) The reasons for the prevalance of fresco are rooted, in the last analysis, in such humdrum factors as a Mediterranean climate that calls for cooling expanses of wall and a rocky terrain that supplies the stones and bricks for building them. In Italy there were fragmentary remains of ancient Etruscan and Roman mural painting; Italian painters learned about the medium from the Greek masters of the Byzantine empire. Yet Italians brought a dazzling combination of resourcefulness, invention, and *bravura* to fresco painting. Much has been lost, but it is more remarkable that so many frescoes on practically every conceivable subject have defied time—frescoes on saints and sinners; princes, prelates, and citizens; mythology, theology, science, and history. Not surprisingly, the central narrative in the traditional story of Italian Renaissance art runs through a line of painters whose greatest works were arguably those done in fresco—

Giotto in the fourteenth, Masaccio in the fifteenth, and Michelangelo in the sixteenth century.

Together with Giotto's murals in Padua and Florence and the scenes from the life of St. Francis in Assisi, the frescoes in the town hall of Siena by Ambrogio Lorenzetti (ca. 1295–1348) are the best known of fourteenth-century Italian fresco cycles. This would be reason enough for including them in this George Braziller series. But there are many other reasons. The Lorenzetti paintings are, almost uniquely among the early frescoes that have come down to us, monumental *secular* pictures. Their presence is an important check on the misleading stereotype that medieval people always saw the world in religious terms. Not only are Lorenzetti pictures frankly worldly, they were present at the creation of a republican image when Europe was still overwhelmingly dominated by monarchs and aristocrats. With astonishing sleight of hand they mobilized political ideas and painting to legitimate a world as new as Columbus's would ever be.

Though I've been looking at these pictures on and off for years, they have never failed to give pleasure and instruction in return. I have good company in the many people who have studied, written about, or only stood admiringly in the Sala dei Nove. While I owe something to them all, I should admit to some dissatisfaction too. One typical response takes the pictures for a realistic portrait of a medieval city-state, either charmingly naive or precociously modern; the prevailing scholarly view sees a passive illustration of ideas about government written down by ancient authorities, especially Aristotle, and medieval scholar-teachers, St. Thomas Aquinas in particular. Either way, Lorenzetti's work becomes something to look through in order to look at a real city or a textual source. This misses what the pictures *are* and what they *do*. They are in their own right intriguing, visually demanding, complicated, and fraught with the need to make one of the great political statements in the history of Western art.

I gladly dedicate the pages that follow to my Berkeley students for teaching me so much and to the putti I hope will succeed them—Gabriel and Frances Dorothy. The transcriptions and translations of the Inscriptions on pages 99-101 are by Ruggero Stefanini, to whom I am most grateful. My thanks to Adrienne Baxter at Braziller for being an ideal editor.

AN ARTFUL REPUBLIC

The Palazzo Pubblico in Siena is still the town hall, community center, urban showplace, and civic boast it was planned to be some seven hundred years ago. Its soaring campanile, or bell tower, provides the first glimpse of town across the rolling hill country of Tuscany between Florence and Rome. The town is built along three ridges that descend and intersect at this red brick mass of a building and its shell-shaped piazza (fig. 1). Business, politics, festivals, and gossip, and admiring travelers have gravitated here since this marvel of a cityscape took shape between 1300 and 1348.

Like other town halls in northern and central Italy that date from the late twelfth century on, Siena's was one of a kind, true to type yet unique. The towns of Italy set the pace in one of the great boom periods of European history, the maligned Middle Ages, which, as modern historians have shown, were hardly "dark," "backward," or "Gothic." Italian towns were far more numerous and larger than other European towns. Siena's early-fourteenth-century population of around 30,000 was minuscule by modern standards and modest compared to urban centers of more than 100,000, such as Venice, Milan, and Florence, but it was probably twice as large as London's. The business corporation, the bank check, the insurance policy, and the great international industry of the middle ages, the wool trade, were all Italian inventions. City-state politics, beginning with self-government by elected officials, seemed revolutionary in a world used to being ruled from above by a feudal hierarchy. All this called for a dynamic culture that, at its best, gave new currency to the old Latin terms for urban life—civic, civilized, and urbane.

With their wealth, civic pride, and technical know-how the townspeople of medieval Italy launched the greatest public works campaign in Europe since antiquity. The centerpiece practically everywhere was the town hall and the cathedral, and every town sought to outshine its rivals with the resources at hand. A proper town hall had to have an imposing façade, a tower, and a piazza, but the building material was usually local brick or stone, towers were custom designed, and a square might be more or less expansive or symmetrical. Civic boosters could always proclaim the results superior to any competition.

In Siena the palace and the *campo*, the "field" that the square had once been, were done in brick, in a shade

9

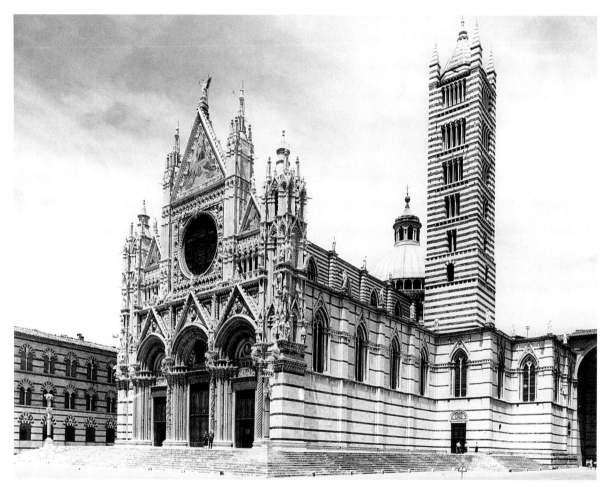

Figure 2: Cathedral, Siena. An expansive program of alterations largely paid for and supervised by the republican government after ca. 1260 transformed a modest Romanesque building on the city's highest hill into this sumptuous edifice. It served as the bishop's church, a civic temple, a ritual stage, and a focal point of devotion. The ecclesiastical and civic centers of Siena were simultaneously developed on a lavish scale, though at an irregular pace, until the Black Death of 1348. Works for the Cathedral and the adjoining Baptistry were commissioned from the greatest artists, among them Duccio, Donatello, Lorenzo Ghiberti, Pinturicchio, and Michelangelo.

artists still call "burnt sienna"; architectural details were added in pitted whitish stone, the local travertine. The extraordinary height of the campanile was dictated by its location at the bottom of the low-lying piazza and by the principle that it should be taller than any other tower in town, including the cathedral's on the hill of Castelvecchio (figs. 2–3). Other distinctly Sienese variations included the attachment of a chapel (1352–76) on the west corner of the Palazzo Pubblico's façade and the *Fonte Gaia*, or "Joyous Fountain," at the head of the square, completed in 1419 and so called because of its reception in a hill town worried to this day about its water supply. The town coat of arms, a white-and-black shield, was emblazoned above the palace's Gothic trefoil windows—themselves a distinctive Sienese touch legislated for other buildings around the *campo*. We can easily imagine the Sienese scoffing at the Florentines' dull beige palazzo, with its lower campanile, skewed façade, and cramped piazza.

The interior of Siena's palace followed a fairly standardized plan (fig. 4). The ground floor included a courtyard, offices, and storage space; the second floor was mostly given over to meeting rooms, the most important of them with mural paintings illustrating real and imag-

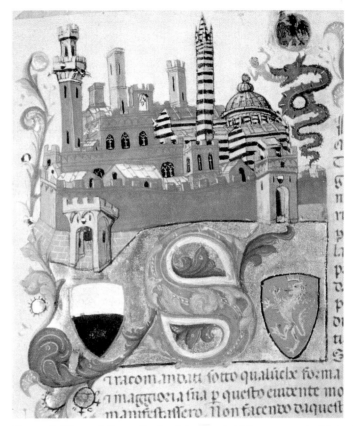

Figure 3: View of Siena, *Book of the Censi*, 15th century, Archivio di Stato, Siena. Flanking the decorative "S" are the *balzana* (the white-and-black escutcheon of the Commune) and the rampant lion of the *popolo*, or "people," of Siena. The eagle and dragon on the upper right are emblems, respectively, of the Holy Roman emperor and the dukes of Milan, Siena's allies at the time of this document.

ined civic achievements. Extravagance was the rule because "the beauty, harmony, and honor of the republic"—a characteristic official formula—were at stake. The government spent large sums on banners and tunics; its archives were stored in elaborately painted chests; and mundane volumes of tax accounts were embellished with coats of arms, official portraits, and civic icons. A normally staid notary exulted in 1316 that certain frescoes in the palace were "a delight to the eye, a joy to the heart, and a pleasure to all the senses."[1] The pictures we are concerned with constitute one among several series of Palazzo

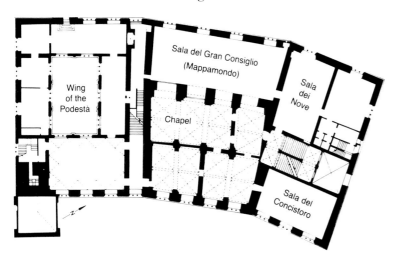

Figure 4: Plan of the second floor of the Palazzo Pubblico, Siena.

Pubblico murals. These included, from the fourteenth century alone, Simone Martini's *Maestà* (Virgin in Majesty) of 1315, a map of the world by Ambrogio Lorenzetti (now lost), and scenes of Sienese victories, subject territories, and military leaders.

The citizen-rulers of Siena were obviously obsessed with the town's image in all senses of the word. Why this was so—and why the Sienese were particularly drawn to color, contrast, glitter, pattern, and sinuous line—is a long-standing mystery. Some of the oldest explanations sound quite modern today. They emphasize the environment: the hill air and light; the intricate patterning of the woods, vineyards, and grain fields around Siena; the mineral colors of the more distant landscape. The busy piazza, the bright emblems of neighborhood societies (the Dragon, the Goose, the Caterpillar, the Giraffe, and so on), the bustling traffic along the main north-south highway and along the branching, twisted streets, all made for a visual feast. As elsewhere in Italy, but conspicuously so in Siena, new urban wealth came together by marriage or business with the swagger and extravagance of old magnate families boasting estates in the country and towers in town. Despite (and because of) sumptuary laws that regulated private display, social position showed in the cut of

a tunic or the color of a dress, the number of guests at a feast, or the art one could afford. Private competition called accordingly for all the more ostentatious public demonstration, a kind of civic exhibitionism designed to mobilize yet contain centrifugal forces. Some of that old potlatch spirit comes to life in the *corsa del palio*, the horse race in the piazza that transforms the town into a medieval pageant twice each year. During the festivities, the neighborhood societies (*contrade*) aim to outshow their rivals' costumes and banners and to win the race but everybody ultimately joins the civic spectacle.

We miss something important if we are too obligingly taken in by all this civic showmanship. The city fathers afterall needed distractions. Consider the following facts, as they must have done often and anxiously. Siena was only one-third the size of its arch rival, Florence, barely thirty miles to the north; it was landlocked in the rural south of Tuscany, with no ready access to the sea, no river, not even a reliable water supply. The Sienese lacked a major large-scale manufacturing industry (there were as many people working in the wool business in Florence as there were inhabitants in Siena); the economy depended disproportionately on the vagaries of banking and the transport trade. The political situation was never very reassuring. Divided into three geographical and administrative parts, then subdivided into dozens of turf-conscious neighborhoods, Siena was notorious for its internal quarrels. The high point in its political history came half a century *before* the building of the Palazzo Pubblico (in 1260), when the Sienese and their allies routed the Florentines at Montaperti, six miles east of town.

As it happened, this was one of the last victories of the pro-imperial Ghibelline alliance against the Guelph supporters of the pope in a century-long struggle over Italy. Fifty years later Duccio di Buoninsegna was commissioned to paint the patron saint of the victory at Montaperti. His *Virgin in Majesty* (fig. 5) replaced another on the high altar of the cathedral. The seventy-odd panels of Duccio's masterpiece glittered in gold and color as it was paraded through a town whose public image had grown more splendid in inverse proportion to its declining fortunes. With the defeat of the Ghibelline cause, Siena had been forced to turn Guelph in 1270. Its merchants and bankers were losing to the competition, and its territorial boundaries, if not its ambitions, had receded. Artists tended to repeat themselves in what became an archaic "Sienese manner." For two generations after the mid-fourteenth century the most influential

Sienese were the tough-minded local saints who flailed away at the sins of the town and the world—St. Catherine (1347–80) and San Bernardino (1380–1440).

With this in mind, we can better understand both the lure and the veil in Sienese public art. For all its jaunty elegance, the Palazzo Pubblico was a defensive fortress whose battlements and tower were not just for show; its scale is excessive and overbearing in a town that can be traversed in five minutes and walked from one end to the other in fifteen. Brick may be beautiful, but it is also cheap—the Florentines, who customarily faced brick with stone or plaster, must have found Siena's palace stinting and provincial. While the Sienese love for decorated surfaces testifies to a taste for beautiful things and an impressive willingness to pay for them, there is something disingenuous about it too, as if the purpose were to cast time under an aesthetic spell.

In sum, art was political and politics were artful in many ways in the Sienese republic. Ambrogio Lorenzetti, as we shall see, was a true native son.

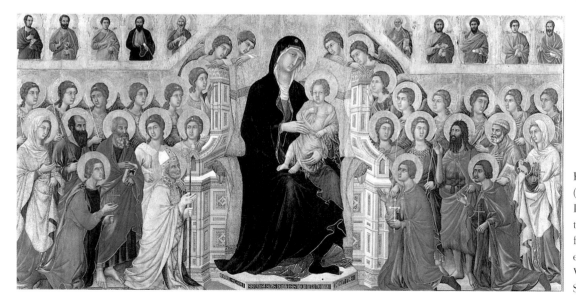

Figure 5: Duccio di Buoninsegna, *Maestà* (detail of front), 1315, Museo dell'Opera del Duomo, Siena, formerly on the high altar of the cathedral. This stupendous altarpiece, some five yards long, its reverse side paneled with episodes from the life of Jesus, shows the Virgin Mary in Majesty as the protectress of Siena—a Sienese civic icon.

COMMISSION AND MISSION

Since the early twelfth century, a shifting combination of republican councils and magistrates governed Siena. Following a distinctive Italian political pattern, the republic had originated as a voluntary commune of leading men who usurped the powers and responsibilities of an imperial count and the bishop. During the thirteenth century a new wave of prosperous men calling themselves the "people" (*popolo*) succeeded in grafting their own institutions onto the commune amid fierce conflicts between old and new families and factions. As a result of one of those tortuous political arrangements for which the Italians were already notorious, a council of nine citizens was formed between 1287 and 1355. These Nine Governors and Defenders of the Commune and the People became a "popular" institution in a republic that was neither very democratic nor altogether submissive to the older magnate elite. The Nine might best be described as a coordinating committee and executive board for a large council of three hundred members and three smaller commissions of tax officials, merchants, and knights. Together these councils embodied the sovereign authority of the republic.

But Italian politics was never so simple as this. The Holy Roman emperor in Germany was still the nominal overlord of the republic and indeed of much of the Italian peninsula—whenever he was powerful or foolish enough to claim it. The head of the dominant pro-papal Guelph party was the French king of Naples, and the *podestà*, an outside official appointed for a six-month term, was the chief magistrate and executive head of the Sienese government, although this position was sometimes contested by the captain of the *popolo*. To complicate matters further, the large and small citizens' councils served for terms of six months or less upon selection by labyrinthine electoral procedures. By statute, every two months a wax ball was drawn containing the names of a new panel of nine "good and lawful merchants" from each of the town's three main districts. By oath, they were pledged to use "every means possible" for "the conservation, augmentation, and magnificence of the present regime."[2]

Art was one of those means, as we have seen. The Nine had to be provided with a suitably impressive space (figs. 6–7). They also needed living quarters because the laws of the commune, guarding against what we would

15

call "lobbying," required them to spend their term of office in the east wing of the palace—the west wing was occupied by the *podestà*. Their meeting hall and audience chamber was an oblong room strategically located between the office of the tax officials and the large hall of the Council of the Bell, so called because its members were summoned by the town crier and the ringing of bells. The dimensions of the Sala dei Nove (Room of the Nine) or, as it was described on occasion, the Sala della Pace (Room of Peace) were not grandiose—14.04 x 7.07 meters, to be exact. But its significance was large as the nerve center of the Sienese republic and the pictorial bible of a republican tradition.

We know nothing about a commission for frescoes beyond the record of payments between 1338 and 1340 to the Sienese painter Ambrogio Lorenzetti for "figures painted and located in the chambers of the lords Nine."[3] This leaves us to infer likely conditions from contemporary practices. We are well informed about these thanks to surviving contracts, workshop manuals, and the physical evidence of the pictures themselves.

The painter would almost certainly have worked from a contract specifying materials, subject matter, and payment schedule. This would have been a business trans-

action in which the customer was supposed to be right. Reversing modern priorities, materials occasioned more discussion than the artist's style. Although a contract normally indicated, for example, whether the blues were to be ultramarine or less expensive azurite, or whether the gilding was to be gold leaf or a substitute, it did not necessarily distinguish between the master's and the assistants' hands. Creative inspiration was subordinate to the client's requirements for subject matter, size, and motifs such as preferred patron saints or settings. Pictures priceless

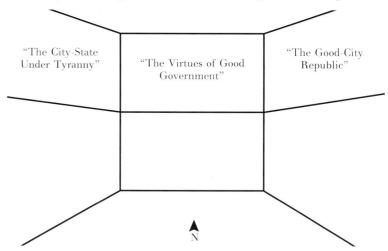

Figure 6: Plan of the Sala dei Nove. Originally one entered the room from a door, now blocked, at the south end of the east wall (see plate 6). The first mural seen would have been "The City-State under Tyranny."

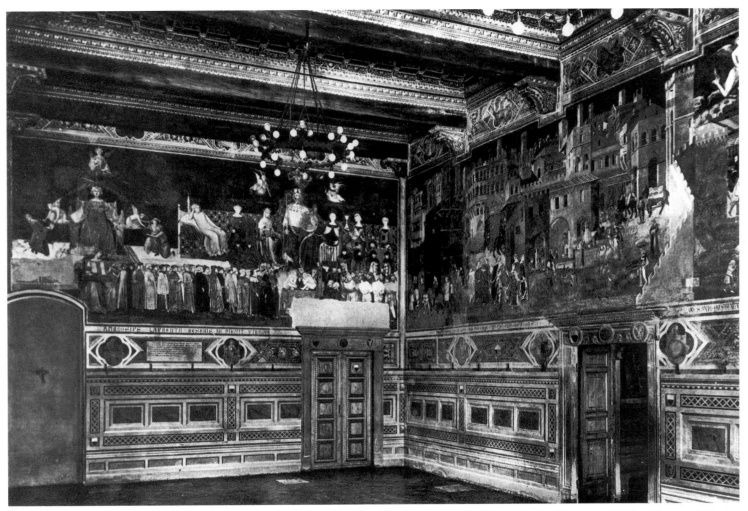

Figure 7: Interior of the Sala dei Nove, north and partial view of east walls. The Nine probably sat under the fresco of "The Virtues of Good Government" on the north wall. The door on the left side of that wall led to the quarters of the Nine. The door to its right was cut later, obliterating the medallion of Rhetoric originally painted there. The door on the east wall, another later addition, leads to the large meeting hall of the Council of the Bell. The tax officials had their office (Ufficio della Biccherna) to the west of the Sala dei Nove.

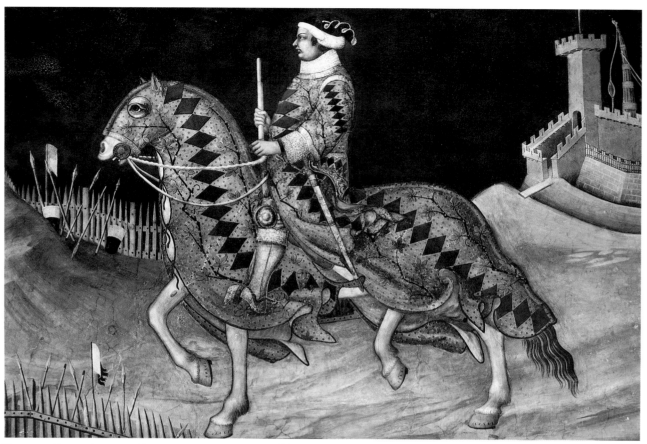

Figure 8: Simone Martini (?), *Guidoriccio da Fogliano* (?), ca. 1338(?), Palazzo Pubblico, Siena.. Among the Sienese victories commemorated in fresco in the meeting hall of the Council of the Bell, this imposing scene was until recently regarded as a masterpiece by Simone Martini. An inscription below dated 1338 suggests that this image shows the War Captain of Siena at the siege of Montemassi, one of the last feudal strongholds in Sienese territory. However, two American scholars, Michael Mallory and Gordon Moran, have pointed to inconsistencies between the written record and the picture and to technical evidence indicating that this picture overlaps the edges of adjacent fresco painting from the fifteenth or sixteenth centuries. In the mid-1980s another fresco showing a fortified town and two figures, one of them a soldier, was discovered below the one illustrated here. It remains uncertain as to which fresco, if either, represents the real Guidoriccio da Fogliano.

today were a bargain in comparison with "necessary" military expenditures—Lorenzetti's frescoes probably cost the Sienese less than maintaining a cavalryman for half a year. The government spent more substantial amounts on public ceremonies, costumes, and banners. If a celebrated portrait of a hired general just outside the Sala dei Nove turns out to be a hoax, as has been claimed in a furious art-historical controversy, then the regime may have spent less for pictures than we have supposed (fig. 8).

Fresco painting was the medium of choice for public rooms in Siena as elsewhere. It suited large expanses of wall. It was versatile, durable, and, not least important, cheap compared to likely alternatives—mosaic, tapestry, marble, or stained glass. Perhaps Lorenzetti's contract stipulated the *buon fresco* that painters of his generation were perfecting. In "good fresco" pigments dissolved in limewater are applied to daily patches (*giornate*) of thin, wet plaster so that they bond chemically with the wall. Partly because paper was expensive, painters normally worked from charcoal drawings and reddish brown underpainting (*sinopia*); they applied these on a rough plaster layer (*arriccio*) that had been troweled onto the original wall surface to create a moisture barrier and a support for the final layer (*intonaco*). Some materials required special handling, such as gold leaf or the cheaper blue substitutes for ultramarine; they were likely to flake away or change appearances (this presumably accounts for the deteriorated gilt lettering and patchy blue backgrounds in the Sala dei Nove). Since luminous colors were highly valued, painters did not darken their pigments "down" for modeling and shadows but lightened them "up" from the pure tone by adding white (or sometimes different accent colors). They did not mix colors except when there was no alternative, because mixed colors are less intense. The limited palette, the juxtaposition of pronounced colors, and the glowing highlights of the pictures in the Sala dei Nove are hallmarks of *buon fresco*. (See the Glossary, p. 103, for further explanations of the technical terms.)

Such an elaborate official project dictated careful planning and close instructions. The precise details may not have been written down, but there must have been preparatory diagrams or sketches of some sort. These would have entailed lengthy discussion between the painter and—since this was how official business was done in Siena—a committee overseeing the project. Artists as a class were still grouped with craftsmen—the true "artist" was a university graduate, a "bachelor" or "master" of arts. In Lorenzetti's case, however, we can be certain that

the painter participated fully in the planning. His reputation belies two clichés at once: that artists were always low-status craftsmen until the Renaissance and that they were willful eccentrics ("born under Saturn," as astrological lore put it). Biographer and artist Giorgio Vasari, looking back in his mid-sixteenth century *Lives* of Italian artists, recalled Lorenzetti's reputation as a cultivated man, "always frequenting men of letters and scholars." Vasari shamelessly exaggerates the qualifications of his fellow artists, but we do know from the records of the Nine that "Magister Ambrosius Laurentii" spoke "with his wise words" for measures strengthening the republican constitution.[4] This tantalizing reference is consistent with the public, occasionally bookish character of his major pictures. Among his works that have long since disappeared were frescoes for the main town hospital and "Roman histories" for another public building; his world map in the large council hall adjacent to the Sala dei Nove featured the "empire" of the little republic. The surviving religious paintings include an altarpiece of the Annunciation for the tax officials (fig. 9) and a frescoed Madonna in an arcade of the Palazzo Pubblico. Lorenzetti was evidently a citizen in good standing, something like an official painter and a kind of cultural bureaucrat.

If the Sala dei Nove project was a republican commission, both on account of the client and the collective effort involved, it also had a republican mission to perform.

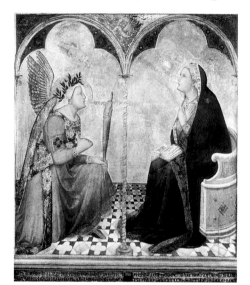

The main medieval tradition of political thought deemed monarchy the best form of government; in practice, monarchical or seigneurial regimes ruled over most of Europe. For Lorenzetti to make the case for republican politics meant knowing how its val-

Figure 9: Ambrogio Lorenzetti, *Annunciation*, 1348, tempera on panel, Pinacoteca Nazionale, Siena. The last signed and dated work before Lorenzetti's death in 1348, this painting was commissioned by the Tax Officials, whose names are inscribed on its base; it hung in the meeting room of the Concistoro, a composite deliberative council that included the Nine. The figures are solemnly monumental within the illusion of space created by the geometrical pattern of the pavement, yet the arched setting, raised details, and gold background remain assertively traditional. The inscription between the angel and the Virgin originally read: *non erit impossibile apud deum omne verbum* ("For with God nothing shall be impossible," Luke 1:37).

ues should *look*, and no one had yet given the full demonstration that seems to have been expected of him. Since republican thinking is always reluctant to concentrate power in a privileged few—say, a king who embodies the realm in his own flesh and family—it must somehow disperse authority in the bodies of its citizens. Where monarchy personalizes politics, republicanism posits impersonal principles that rise above particular interests. Republican ideology envisions public culture that aims at the highest human ideals while also mobilizing the productive diversity of the people. Its utopias are simultaneously transcendental and mundane.

To meet these challenges, Lorenzetti assembled a common stock of precedents. Art historians have often emphasized instead the painter's originality in what turns out to be an unintended tribute to his deft use of a conventional pictorial repertory. Not least of the fascinations of his work is that even though the motifs can usually be traced to workshop practice, Lorenzetti persuades us that we are seeing them for the first time.

From first glance, we can see that the images celebrated for their picturesque appeal are actually geared to texts and to writing: they are studded with labels and quotations, framed by captions, flagged with explanatory inscriptions. (See Inscriptions in the Sala dei Nove, pp. 99-101.) We are literally told what we are seeing and how to see—so much so that we can read the texts without even looking at the pictures and still get the basic message. A "pre-Renaissance" insistence on words has reappeared in the art of our own century, ironically enough, the age of film and video; we have, for example, Cubist newsprint collages, advertising labels in Pop Art, and the print-media installations of Postmodernism. Lorenzetti's fourteenth-century version testifies to the authority of the written word and to its heady appropriation by lay readers who were breaking a near proprietary monopoly by the clergy and secular experts such as notaries and lawyers. It is a pardonable exaggeration to say that parchment, paper, and ink were the body and blood of the Italian city-republics. Writing was essential for business, administration, record keeping, and an articulate civic culture. These city-republics already shared what the arch theorist of absolute monarchy, Thomas Hobbes, would condemn as a seditious mania for written covenants, constitutions, and "the flutter of books."[5] The literacy rate may have run to more than 50 percent in Siena—it was probably much less in the rest of urban Europe. For literate citizens reading and

writing were a symbolic and very real challenge to the inherited privilege of nobility and a hedge against their illiterate dependents in the chess-like hierarchy of the social order.

Like the inscriptions in the Sala dei Nove, the Sienese republic was bilingual (although, of course, not all republicans were), and like the Italian and Latin documents in its archives, the two languages serve distinct functions in Lorenzetti's frescoes. The vernacular texts around or in the pictures, though distracting and hard to read, would have been recognized by contemporary readers as the gloss that vouched for the authority of a central text. They addressed the reader directly in a rhyming Italian that would not be out of place in an anthology of vernacular poetry written by Lorenzetti's contemporaries. Dante had only recently defended the dignity of the vernacular, but Latin was still the official language of the church, court, university, government—and of Dante's own defense of "vulgar eloquence." In an easy compromise, council meetings were conducted in Italian but recorded in the more prestigious tongue, while statutes in Latin were translated on request into Italian.

This situation is not unlike that in the Sala dei Nove. Latin is reserved for biblical text, civic mottoes, and the identifying labels of what amounts to a picture-book encyclopedia. Lorenzetti's self-important "signature" in Latin reads as a none-too-subtle bid for high status. Quite apart from anything the Latin actually says, we are being assured here—not coincidentally in gold lettering—that the Republic of Siena is a highly respectable institution, perfectly familiar with the gold standard of high culture. What we are not told is that the authorities did not have to be read in the original. There were vernacular translations in medieval anthologies, most importantly *The Great Treasure* (ca. 1265) by Ser Brunetto Latini. This scholarly Florentine notary who was Dante's mentor prefaced his compilation with the claim that it included everything necessary to know for governing cities (fig. 10). Modern scholars have turned over whole libraries looking for Lorenzetti's "sources," but he could have made do with this one sturdy textbook, the first encyclopedia for lay readers. Erudition, originality, or deep thought were not necessary or even wanted. It was commonplace wisdom that cast an aura of legitimacy on the Sienese republic, precisely because it was commonplace. Where the inscriptions try to show off technically sophisticated philosophical distinctions, they get them wrong (p. 54).

But if writing was so important, why have pictures at all? This is not such a farfetched question. Even the scenes in the great panorama of the ideal city and country on the east wall can be "read" as illustrations of texts and as texts in their own right. It has been argued, for example, that the activities depicted in the town and countryside represent the seven "mechanical arts," the counterparts of the "liberal arts" in medieval encyclopedias. With varying degrees of plausibility scholars have related various scenes to astrological texts, medieval health manuals, and lists of occupations associated with the months of the year in medieval calendars.

My own conclusion is that the pictures—like all great pictures perhaps—were overdetermined, that is to say responsive to the conditions of their making but impossible to reduce to any single condition. No doubt Lorenzetti painted pictures, not just texts, because that was his business and the tradition for public rooms in Siena besides. Pictures were supposed to have the advantages over words that the church had formulated in defense of sacred images: they could be understood by the illiterate, inspire emotion, and be vividly remembered. There was a large workshop stock of formulas for illustrating or, more technically, "illuminating" concepts spelled out in texts. As

comparisons in the Plates and Commentaries section will suggest, many of the "naturalistic" details in the frescoes came to Lorenzetti more or less directly along a network of models and precedents. What makes them different, apart from individual variations, was his marvelous ability to combine such a large selection of motifs in a single place on a monumental scale.

This was a republican and a Sienese difference. The seemingly natural and realistic images of city and country life on the east wall served as visual evidence that republican virtues really worked in the world, or at least in a simulacrum of it. Here was the plenitude of productive energy that republican ideology promised over and against the court, the castle, and the church. Here the republic triumphed over reality in art.

Figure 10: *Ser Brunetto Latini and a Reader*, Biblioteca Medicea Laurenziana, Florence, Strozzi Ms 146, fol. 1.

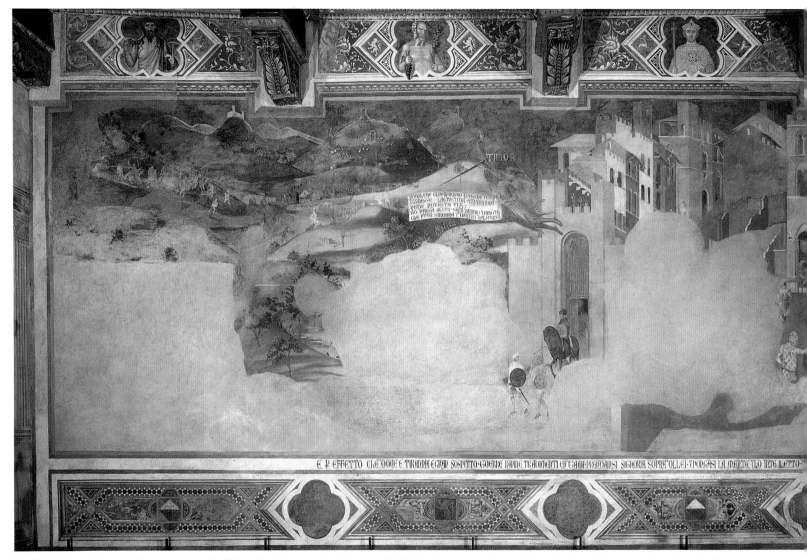

Plates 1–2: Sala dei Nove, west wall, "The City-State under Tyranny." This is the scene that confronted the visitor entering through the original door in the southeast corner of the room. The usual title, Allegory of Bad Government, is a modern invention. A fifteenth-century source describes the fresco simply as "War." I have changed the name to reflect the content of the picture and the inscriptions.

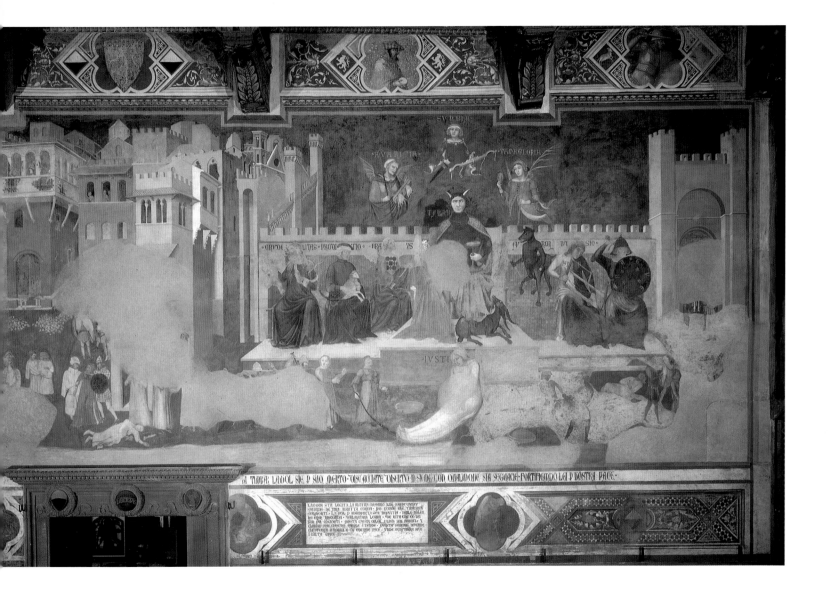

A REPUBLICAN ITINERARY

The main entrance to the Sala dei Nove was originally a door (now a walled-up niche) in the southeast corner of the room near the window. To enter there was to face violent scenes, sinister personifications, and menacing inscriptions on the west wall (plates 1–2). Dante's *Divine Comedy* also begins in "a suffering city" (as the poet calls hell), and Lorenzetti's painted room, like the poem, proceeds through the three "realms" of a redeeming journey. The three frescoed walls are both separated and joined by the simulated architecture of the painted frame, the inscriptions around the room, and the sweep of painted light from left to right. Too large and sequential to be completely taken in from a single vantage point, the pictures put the reader-viewer through the paces of a republican itinerary, from the dark oppression of tyranny to a radiant earthly paradise.

A winged harpy labeled "Timor" (Fear) opposite the original entrance holds a scroll. *This* land, we read, has subjected justice to tyranny—no one passes without fear of death. The damaged state of the picture gives the message a surreal effect. And there, to the right along the walls of a desolate city, Tyranny presides, sallow and monstrous, surrounded by a sinister court of vices and surmounted by an evil trinity: Avarice, Pride, and Vainglory. The figures are extravagantly, melodramatically wicked. Misbegotten hybrids of man and beast, equipped with useful instruments put to perverse uses, they belong to the prolific lineage of the devil and his minions in literature and art. But this is not the usual lineup of sins from a fire-and-brimstone preacher's list. The vices alongside Tyranny are social and political failings, rather than individual sins. Tyranny was no merely symbolic threat when upstart little Caesars were coming to power by force or fraud in fourteenth-century Italy. The shudder of recognition in Siena must have been all the more unsettling, because the real and imagined faults of tyrannical rule were the same ones that city-republics were often blamed for, especially avarice and discord. The dystopia on the west wall was something that the citizens of Siena feared in their republic—and in themselves.

The images and inscriptions are part admonition, part lesson—either way, a form of political therapy. The dire consequences of injustice are staged and analyzed—but only in paint, where they could be exposed, scorned, and

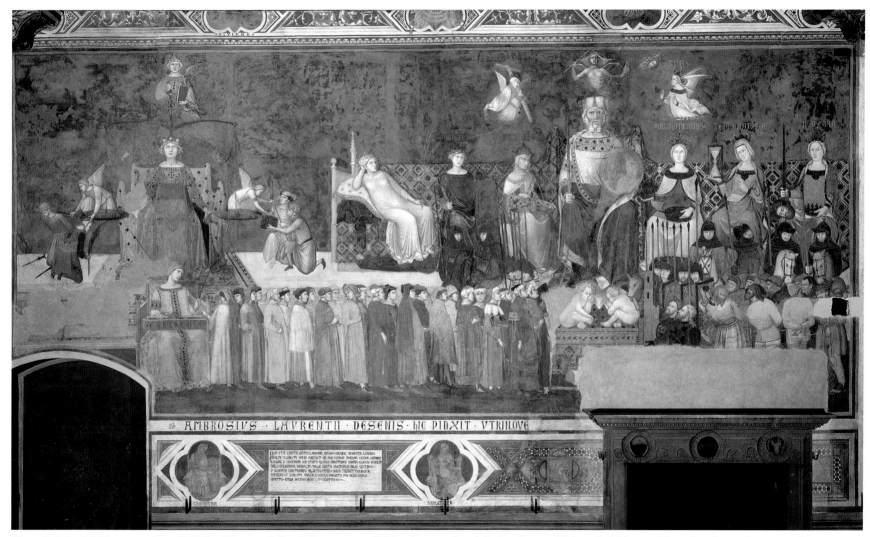

Plate 3: Sala dei Nove, north wall, "The Virtues of Good Government." The door on the right is a later addition. Strickly speaking, the picture is not, as the modern literature calls it, an "Allegory of Good Government"—hence the new title is given here.

painlessly mastered. With a further turn to the right, to the north wall, the vices are countered and clearly outnumbered by a court of virtues and their devotees (plate 3).

The fresco on the short north wall is not so much an "allegory of good government"—the usual modern title—as an illustrated diagram of political virtues. Following the inscriptions and the light around the room, it draws attention as a luminous middle realm to the menacing contrast on the left ("sinister" in Latin and Italian) side. The fresco cycle is visually centered here, as if to purge the taint of the vices before moving on to the full flowering of virtue (plate 4).

An enthroned Justice and her attendants on one side serve as a visual hinge between the court of Tyranny and the (considerably larger and visually richer) court of Common Good, or the Commune. The virtuous court is from top to bottom the counterpart of its negative other: both have three distinct levels, with three superintending personifications at the top; in each, three figures on either side set off a commanding figure in the middle; the zone beneath each court shows "actual effects," respectively, of vice and virtue.

The composition is more or less symmetrical, quid pro quo: for the hovering triad of evil on the west wall, a trinity of the theological virtues (Charity, Faith, and Hope) on the north; for the six vices on their bench, six enthroned virtues; for Tyranny, the imposing personification of the Common Good; for the injuring tools, the reassuringly familiar attributes of the virtues—the olive branch of Peace, the hourglass of Prudence, the shield and scepter of Fortitude, and so forth. Besides countering the vices, the virtues win out through sheer numbers. Twenty-four councillors, squadrons of mounted knights and infantry, and a host of subjects are arrayed together under the virtues and rally around the totem she-wolf with her Sienese Romulus and Remus, Senus and Aschinus.

Here as elsewhere our gaze is repeatedly caught up in details, yet aggressively shepherded back to the overriding theme of justice. The north wall is framed to the left and the right by personifications of Justice. One is the even-handed dispensing queen on her throne, her eyes upturned to Wisdom above her, the other is a lady-executioner brandishing a sword and a gruesome severed male head. Justice is—quite literally—tied into the ensemble several times over. Two cords descend from her scales and are woven together by Concord; the braided rope then passes into the hands of the twenty-four councillors in the middle of the picture, rising to encircle the wrist of the Common Good.

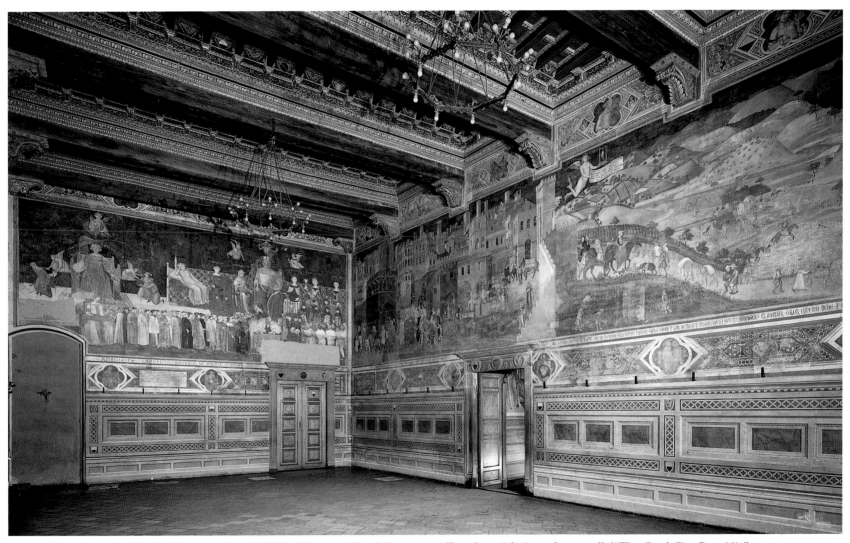

Plate 4: Interior of the Sala dei Nove, north wall ("The Virtues of Good Government") and partial view of east wall ("The Good City-Republic"—a more accurate name than the modern title, "The Effects of Good Government.")

Although the message is quite clear from the images, the inscriptions repeat it, twice in Latin, three times in Italian. Wishful thinking, genuine conviction, or pure propaganda? One thing is certain enough: given the republican preoccupation with diversity and equality, justice was a problematic issue in Siena—hence the virtual fixation on it in the Sala dei Nove. Justice, we read, is the "holy virtue" inducing citizens to make the Common Good their lord. Justice proves that virtue pays in the form of taxes, tributes, and territories. She guards, nourishes, and rewards those who honor her.

The virtues look out from the north wall, where the Nine themselves probably sat. From the head of the room painted and real gazes would have intermingled, reinforcing one another. But visual cues would have drawn attention away from the north wall, as they still do, and toward the east wall on the right, and so to the culmination of the republican message.

Light seems to flow out from the central wall, as if from the virtues (and the eyes of the Nine). The text continues, moving from left to right, but the bottom inscriptions refer back to the theme of justice. Outshining the bleak wall opposite, putting it, so to speak, in the dark, the glowing panorama on the east wall draws the eye into a kind of paradise on earth, the good city-republic with the look (of course) of Siena. This is one of the most famous pictures in European medieval art, and one of the most familiar of all landscape paintings (plates 5–6). It is easy to see why. The panorama is roomy but full of Technicolor details; any number of pictorial anecdotes invite telling and retelling. A whole pictured world arises here, a lost Atlantis.

The fresco has prompted a correspondingly profuse amount of interpretation. The earliest descriptions we have—by the Florentine sculptor Lorenzo Ghiberti in his commentaries on art and by San Bernardino in a sermon, both quite sketchy—date from the first half of the fifteenth century. These accounts refer to little scenes here and there but also recognize a broad moral: security and trade for Ghiberti; justice for San Bernardino. Most subsequent interpretations stress either naturalistic particulars or general lessons rather than the interplay of both.

According to Erwin Panofsky, one of the twentieth century's most influential art historians, Lorenzetti's city and country were "the first post-classical vistas essentially derived from visual experience rather than from tradition, memory, and imagination."[6] A dutiful historian went so far as to count fifty-six persons and fifty-nine

animals in the country as "documents" of social history in pictures. The problem with these approaches is that they ignore both the pictorial conventions within which the painter worked and their programmatic association with categories of knowledge and moral lessons taught in medieval schoolbooks. We find the "liberal" and the "mechanical" arts, astrological influences, and the seasons of the year illustrated in medieval art. Further, dancing was a common visual metaphor for justice and concord. The problem with these interpretations in turn is that general formulas are figured in specific and contingent forms in Lorenzetti's picture. The modern label for such a fourteenth- or early-fifteenth-century style is "late medieval realism." This term has been used to designate both a lingering "medieval" penchant for abstraction and an "early Renaissance" fascination with the visible world.

Lorenzetti's contemporaries knew nothing about these art-historical labels. We can't be sure what the citizens of Siena made of the east wall. Yet we can say—and see—how the great panorama still fulfills republican expectations. The scenes on the east wall are idealized: larger-than-life dancers in ball gowns never twirl in the streets; farmers certainly do not harvest and plant in the same season. The motifs were all well known. Nevertheless, the picture conveys the impression of people acting as good citizens should—freely, on their own, but also for the community's needs. They do so in a space that solicits inspection without fixing a set focus. This is a case in which an older technique—the multiple vantage points used in medieval painting—conveyed the message better than the modern one-point perspective system, invented in Florence in the next century, would have done.

A whole genre of how-to books on government in the thirteenth and fourteenth centuries was called "mirrors" or "eyes" for magistrates. The few surviving minutes of the Nine are full of little incidents to which they cast an attentive eye. The solemn legal formulas of the documents gave them responsibility for overseeing the large and small affairs of the city and the country. The Sala dei Nove panorama is a pictorial version "reflecting" and "seeing" the ideal city republic.

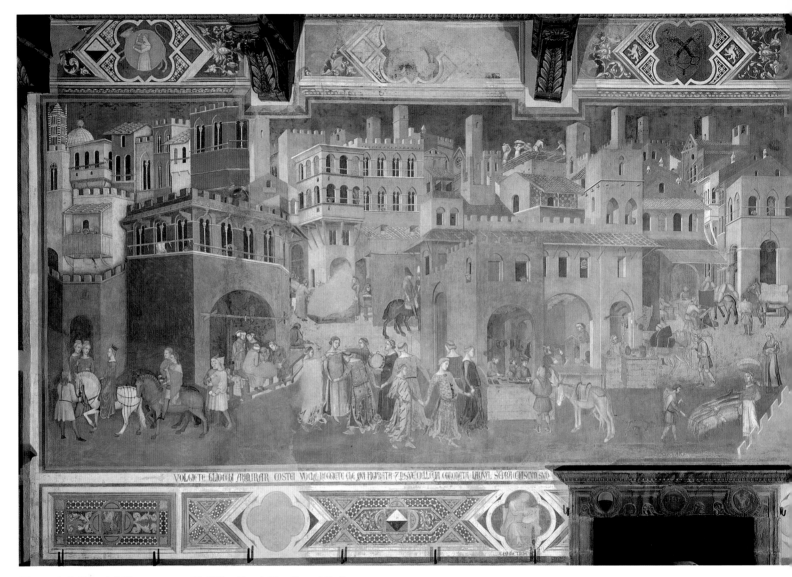

Plates 5–6: Sala dei Nove, east wall, "The Good City-Republic."

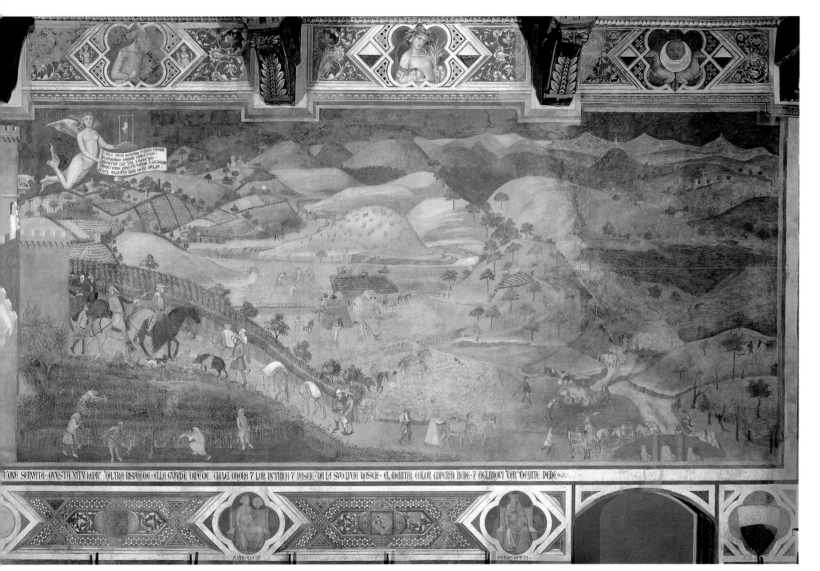

Note the original entrance to the Sala dei Nove.

LEGACY

Ultimately of course art did not save the regime of the Nine. Lorenzetti may have been putting the finishing touches on scenes of plenty when famine struck in 1340. Far worse lay ahead in a century fit, as the Sienese chronicler Agnolo del Tura would say, to end the world. In 1348–49 the Black Death killed at least a third of the population, including, it seems, Ambrogio Lorenzetti. This was only the first wave of a series of epidemics over the course of three generations. While pretending to keep pace with the competition, the Sienese economy never recovered. As for the government of the Nine, the arrival of Emperor Charles IV in 1355 with a force of a thousand knights triggered an uprising at the upper and lower reaches of the social order. There was looting and arson. Records were destroyed, and a broken chest of electoral lists was dragged through the streets on the tail of an ass.

In a very real way, however, art did preserve the regime of the Nine. Their building projects left a lasting imprint on the urban fabric, and many works of art they commissioned, great and small, are still with us. That so much survived was partly the unintended consequence of Siena's long decline, but the survivals are proud witnesses and an affirmation of continuity too. Republican institutions lasted through the rise and fall of a would-be prince, Pandolfo Petrucci, at the end of the fifteenth century. The descendants of the Nine regrouped as a political faction, the Noveschi, which was officially recognized in the councils of government. Not until 1555 did the republic fall to Florence at last, and then only after a long siege by Spanish, imperial, and Florentine forces doing the dirty work of the first Medici duke of Tuscany, Cosimo I. Tenacious beyond the very end, a remnant republic in exile held out in the hills of southern Tuscany until it was abandoned by its allies in 1559.

And yet Siena has been treated as something of an exotic and ineffectual historical peacock. In the romantic version the Sienese have their stunning cityscapes, the mystical look of their saints, their trademark sweetmeats, their weakness for silk costumes, their superannuated styles. Here is the perfect foil to Florence—hill town to valley cosmopolis, the pretty anachronisms of the Sienese versus the modernity of the Florentines. The new historiography tends to be hard-bitten, rummaging in the archives after economic details and political deals, and

partly for that reason inclined to be dismissive. For all their differences, the romantics and the realists have let the dust of the museum settle on Siena.

This is unfortunate. Siena's history prompts reflection on the republican experiment that was the great political project of the Italian city-republics—nowhere more manifestly than in the Sala dei Nove. Republican ideology has traditionally been a precarious series of juggling acts. It needs somehow to balance particular political and social interests while exalting the general good, to celebrate individual enterprise and promise justice, to ascribe majesty to the state in the absence of a king without necessarily falling back on the aura of sanctity in a church. While in theory at least aristocrats and subjects are born to their roles, citizens have to be educated to their public responsibilities, persuaded (or fooled) by the need for civic virtue, and reminded of the consequences of failing to be vigilant.

Much of the lasting significance and fascination of the Sala dei Nove frescoes lies in the fullness and intelligence with which Ambrogio Lorenzetti as a citizen and an artist met these requirements. As we have seen, the commission was republican not only by virtue of the client, location, and theme, but also because it involved a kind of civic conversation over a body of techniques, texts, and images. This was not, to be sure, a very democratic conversation by modern standards, as the political franchise was limited to the relatively well-to-do. Even so, as many as fifty-four citizens sat on the Nine in any given year and the statutes created openings for hundreds of others on other councils and commissions—statistics that could not be equalled in many modern cities or, for that matter, in Pericles's Athens. If Lorenzetti's task was burdened by the desire for comprehensiveness, this, like the proverbial camel, is what happens in design by republican committee—and might be preferred to the leveling efficiency of the autocrat. In any case his masterpiece continues to guide us through its republican itinerary, conjuring up real and imagined enemies in the guise of evil, countering vices with virtues, and rewarding virtue in turn in a redemptive panorama. Rarely if ever has a work of art so visually spectacular contended more deeply with the problematic, perhaps ultimately irreconcilable demands of republican thinking.

NOTES

1. Quoted by Daniel Waley, *Siena and the Sienese in the Thirteenth Century* (Cambridge: Cambridge University Press, 1991), p. 13.

2. From the version dated October 20, 1339, quoted by William M. Bowsky, *A Medieval Italian Commune: Siena under the Nine, 1287–1355* (Berkeley: University of California Press, 1981), p. 55.

3. The documents and early references to the frescoes have been collected by Edna Carter Southard, *The Frescoes in Siena's Palazzo Pubblico, 1289–1539* (New York: Garland Dissertations Series, 1979), pp. 271–77.

4. Giorgio Vasari, *Le vite de' più eccellenti pittori, scultori ed architettori*, ed. Gaetano Milanesi, 9 vols. (Florence: Le Monnier, 1878–85), 1: 525 (there are several English translations of Vasari's *Lives*). The archival record of Lorenzetti's words in council (*sua sapientia verba* [sic]) is discussed in Randolph Starn and Loren Partridge, *Arts of Power: Three Halls of State in Italy, 1300–1600* (Berkeley: University of California Press, 1992), p. 318, n. 83.

5. *Leviathan* 2.21, ed. Michael Oakeshott (Oxford: Oxford University Press, 1957), pp. 140–41.

6. Erwin Panofsky, *Renaissance and Renascences in Western Art* (New York: Harper and Row, 1969), p. 142; for the critical fortunes of the east wall panorama in general, see Starn and Partridge, *Arts of Power*, pp. 46–48.

PLATES AND COMMENTARIES

West wall, "The City-State under Tyranny"

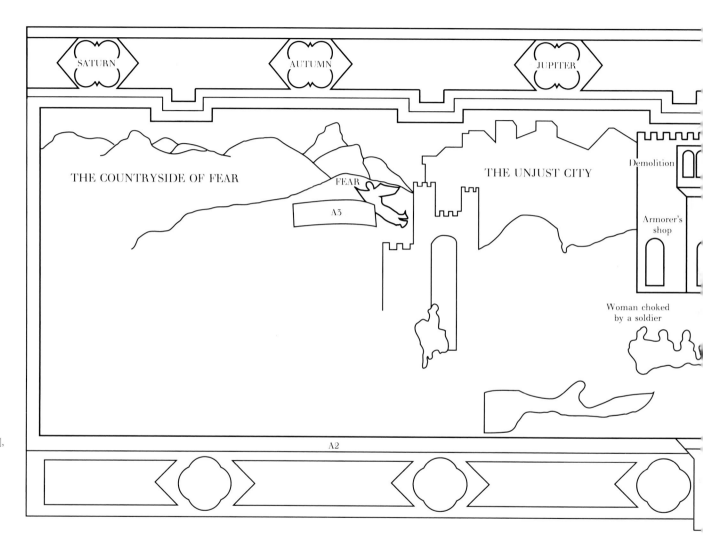

SATURN AUTUMN JUPITER

THE COUNTRYSIDE OF FEAR

FEAR

A3

THE UNJUST CITY

Demolition

Armorer's shop

Woman choked by a soldier

A2

A3

Because each seeks only his own good,
 in this city
Justice is subjected to Tyranny;
Wherefore, along this road
nobody passes without fearing for his life,
since there are robberies outside and
 inside the city gates.

A2

[.
.] and for the reason
that, where there is Tyranny, there are
 great fear,
wars, robberies, treacheries and frauds,
she must be brought down.†
And let the mind and understanding
 be intent
on keeping each [citizen] always subject
 to Justice,
in order to escape such dark injuries,
 by overthrowing all tyrants.
And whoever wishes to disturb her [Justice],
 let him be for his unworthiness
banished and shunned.
together with all his followers,
whoever they may be:
thus Justice will be fortified to
the advantage of your peace.

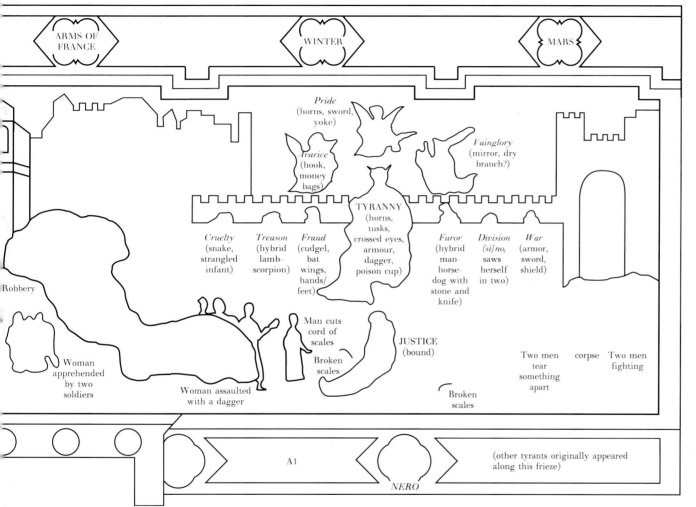

ARMS OF FRANCE

WINTER

MARS

Pride
(horns, sword,
yoke)

Avarice
(hook,
money
bags)

Vainglory
(mirror, dry
branch?)

TYRANNY
(horns,
tusks,
crossed eyes,
armour,
dagger,
poison cup)

Cruelty
(snake,
strangled
infant)

Treason
(hybrid
lamb-
scorpion)

Fraud
(cudgel,
bat
wings,
hands/
feet)

Furor
(hybrid
man-
horse-
dog with
stone and
knife)

Division
(*si/no*,
saws
herself
in two)

War
(armor,
sword,
shield)

Robbery

Woman
apprehended
by two
soldiers

Man cuts
cord of
scales

Broken
scales

JUSTICE
(bound)

Woman assaulted
with a dagger

Broken
scales

Two men
tear
something
apart

corpse

Two men
fighting

A1

NERO

(other tyrants originally appeared
along this frieze)

A1

There, where Justice is bound,
no one is ever in accord for the Common
 Good,
nor pulls the cord [i.e., of civic concord]
 straight [i.e., with force and full
 commitment];
therefore, it is fitting that Tyranny prevails.
She,† in order to carry out her iniquity,
neither wills nor acts in disaccord
with the filthy nature
of the Vices, who are shown here conjoined
 with her.

 She banishes those who are ready to do good
and calls around herself every evil schemer.
She always protects the assailant, the robber,
and those who hate peace,
so that her every land lies waste.

See pages 99–101 for additional information
and notes on the inscriptions.

Timor (Fear)

This grim figure, a flying corpse of a woman dressed in tatters and armed with a dark sword, faces the original entrance to the Sala dei Nove. She belongs to the macabre cast of harpies, demons, and deathly messengers in medieval art. Her scroll announces the overarching theme of this wall: the reign of tyranny, vice, and terror in an unjust land (for the English translation of the text she carries, see inscription A3 on the preceding diagram). Literary personifications of fear appear in classical and medieval texts, including the vernacular compendium Ser Brunetto Latini himself commended for its riches "on the governance of cities," his *Great Treasure* (ca. 1265). The Sienese citizen-poet Bindo Bonichi, who sat on the Nine not long before Lorenzetti began his work, returned obsessively in verse to the evils that would be rehearsed again in paint under Timor's flailing sword. Wherever tyranny prevails over justice—and for Bonichi this can happen in powerful men, whole communities, and the souls of good citizens—we must expect bad faith, avarice, robbery, violence, and "*alcuna nequizia | Et tutti in general della paura*" ("every iniquity, and all in general [to be slaves] of fear").

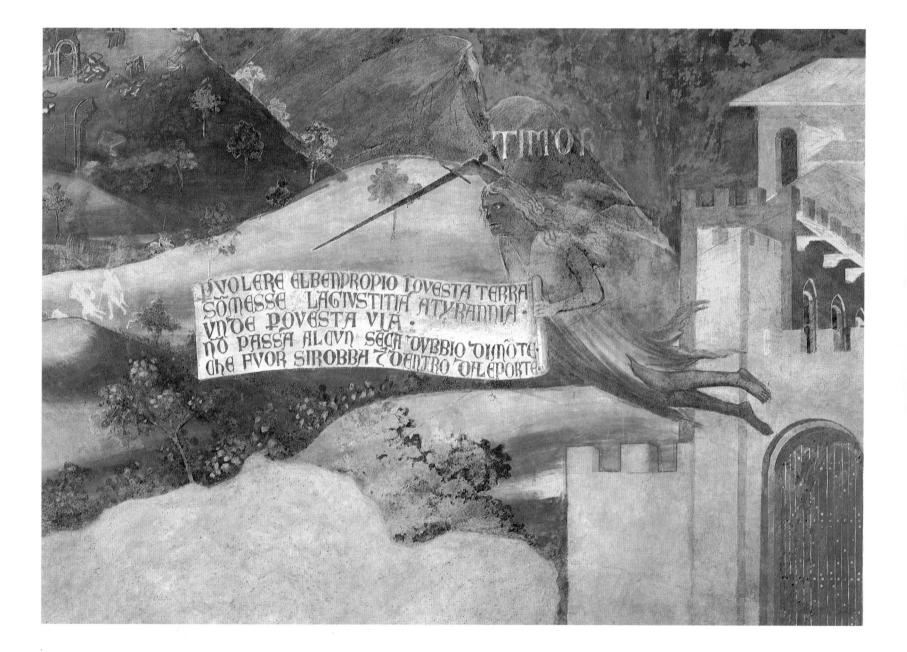

TIMOR

DVOLERE ELBENPROPIO TOVESTA TERRA
SÕMESSE LAGIVSTITIA ATYRANNIA ·
VNDE ROVESTA VIA ·
NŌ PASSA ALCVN SĒÇA DVBBIO DIMŌTE ·
CHE FVOR SIROBBA 7 DENTRO DALE PORTE ·

Desolation and Destruction in the Countryside of Fear and in the Unjust City

The details on the three following pages show Timor's message acted out in the distant countryside and a devastated city. The pictures have suffered from the elements, mostly water damage, but their ruined state is eerily in keeping with their subject. Soldiers pillaging and burning haunt the dark hills; in town, garishly uniformed thugs menace their victims, while a leering figure robs a purse. A body in a white gown lies bleeding from a chest wound with a knife on the ground beside her. Men wielding crowbars dismantle buildings, leaving piles of rubble in the streets. Only the armorer making instruments of war works in his shop.

Lorenzetti's genius here is the combination of a high moral lesson and a kind of tabloid journalism. The viewer begins, as the poet-pilgrim in Dante's *Divine Comedy* does, in hell. These scenes are the dark mirror image of the radiant city and country on the east wall on the opposite side of the room.

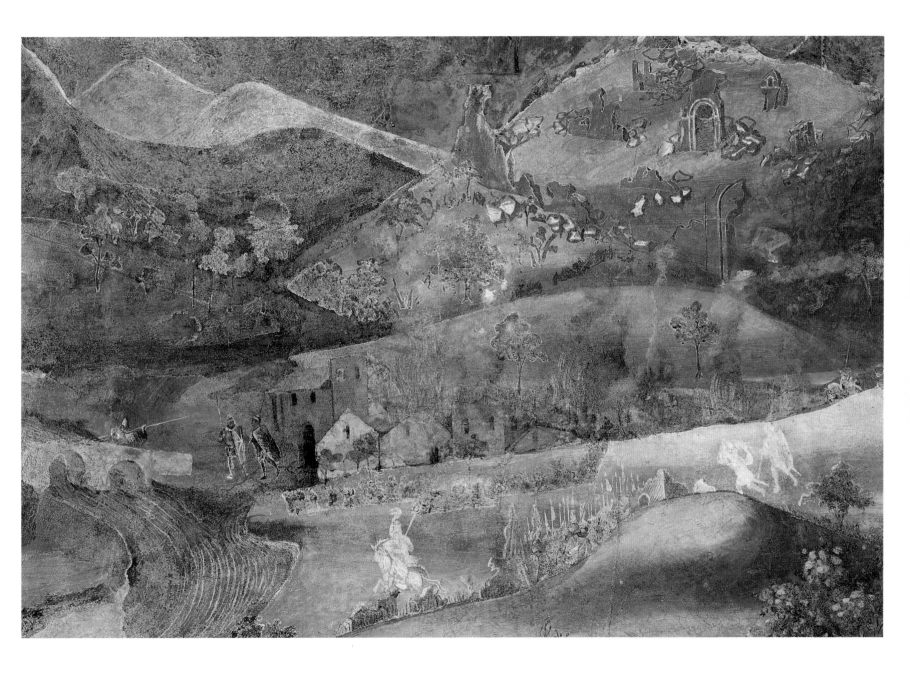

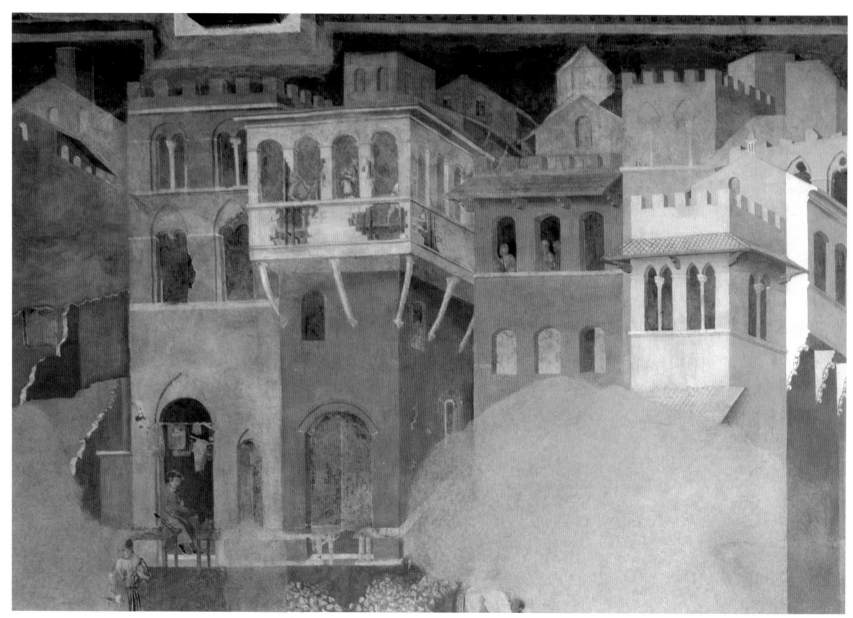

detail, The Unjust City

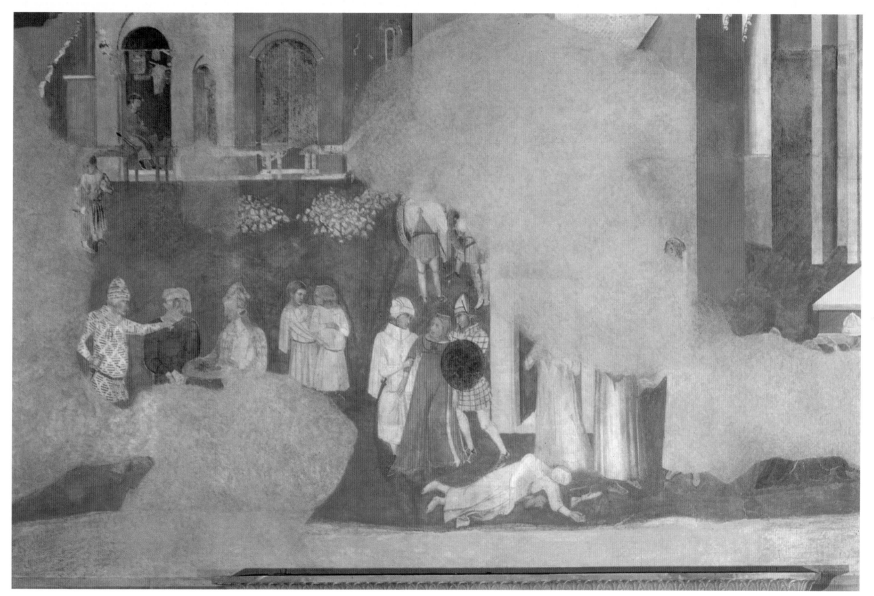

detail, The Unjust City

The Court of Tyranny

To the right, under the battlements of the ruined city, looms the cause of so much desolation: Tyranny and its entourage. Horns, fangs, and a dark cloak are attributes of the devil; the black mascot at Tyranny's feet recalls the biblical passage where Jesus separates the "goats" of unbelief from the "sheep" of faith (Matt. 25: 31–46). The strategies of the tyrant, deception and violence, are suggested by the chalice (a holy vessel in a Catholic mass) and the rock or bludgeon in the figure's hands. The grotesque court is arranged in counterpoint on either side: the schemers—Fraud, Treason, and Cruelty—to the right of Tyranny; the violent vices of Furor, Division, and War to its left. Avarice, Pride, and Vainglory hover above, an anti-Trinity, with Pride reigning as "highest" of the sins, its usual position since the early Middle Ages. Below lies the bound figure of Justice, hair dishevelled, head uncrowned, looking down mournfully as the two large discs of her scales lay fallen at her side. The inscriptions (see pp. 40–41) underscore the nagging anxiety about justice that is a leitmotif in the room and in republican discourse in general.

Lorenzetti here adapts a medieval gallery of biblical horrors to civic purposes. The sinister personifications are not so much sins tormenting the soul as evils disrupting the political and social order; rather than being punished in hell, atrocities are, so it seems, perpetrated against the innocent on earth. A kind of worldly ingenuity and black humor are at play here with medieval conventions of the monstrous—for example, the hybrid monsters like the centaur-wolfman of Furor; Fraud's fair face, bat wings, and gloved hand stealthily clutching a weapon; Division, labeled "*si/no*" ("yes/no") and dressed in Sienese black and white, busily sawing herself in two.

Contemporary authors and modern historians call the fourteenth century in Italian history an age of *signori* (translated as "lords," "princes," or "despots," depending on one's political sympathies). By Lorenzetti's time Siena had some experience with such "tyrants" beyond its borders, but it would not, until much later, have a *signore* at home. The mural on the west wall was a vivid warning and lesson for the Nine and their fellow citizens. The atrocities will probably seem tame to late-twentieth-century eyes and the admonitions wishful thinking.

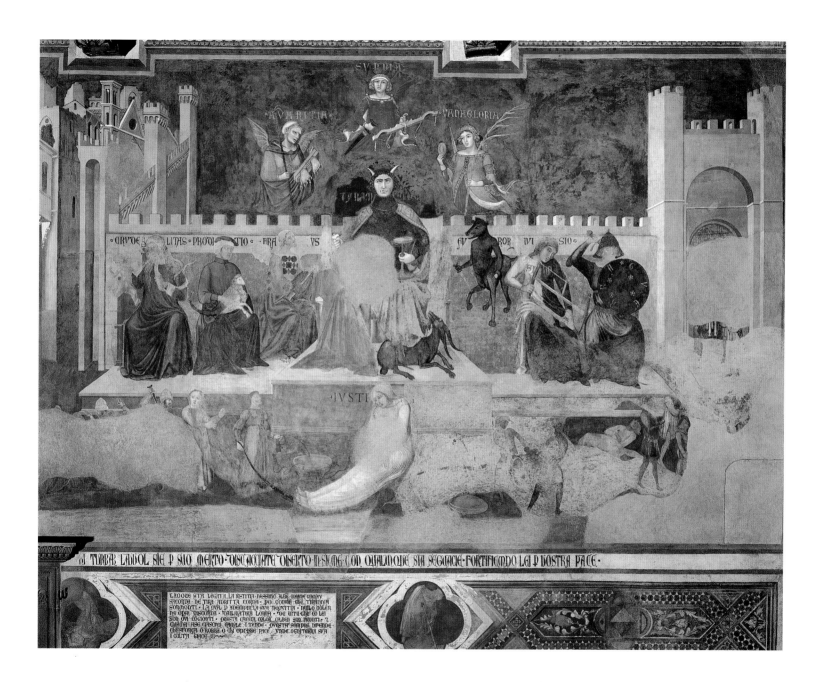

SVPERBIA

AVARITIA VANAGLORIA

TYRANNI

CRVDELITAS · PRODITIO · FRAVS FVROR · DIVISIO · GVERRA

JVSTI

LADOVE STA LEGATA LA IUSTITIA · NESSUNO ALBE CONE AL CHMUN
SACCORDA · NE TIRA ADRITTA CORDA · PO CONVIE CHE TYRANNIA
SORMONTI · LA QVAL P ADEMPIR LA SUA NEQVITIA · NVLLO VOLER
NE OPRA DISCORDA · DAL LA NATURA LORDA · DOE VIRTUDE CO LEI
SON OM COGIONTI · QVESTA MENTE COLOR CHEN SON PRONTI · E
CIASCUN PER CIASCVN QVIMPLE I TIENDE · QVESTA SEMPRE DIFENDE
CHI STORCE O ROBBA O CHI ODIASSE PACE · PVRHE OGNI TERRA SVA
I COLTA GIACE

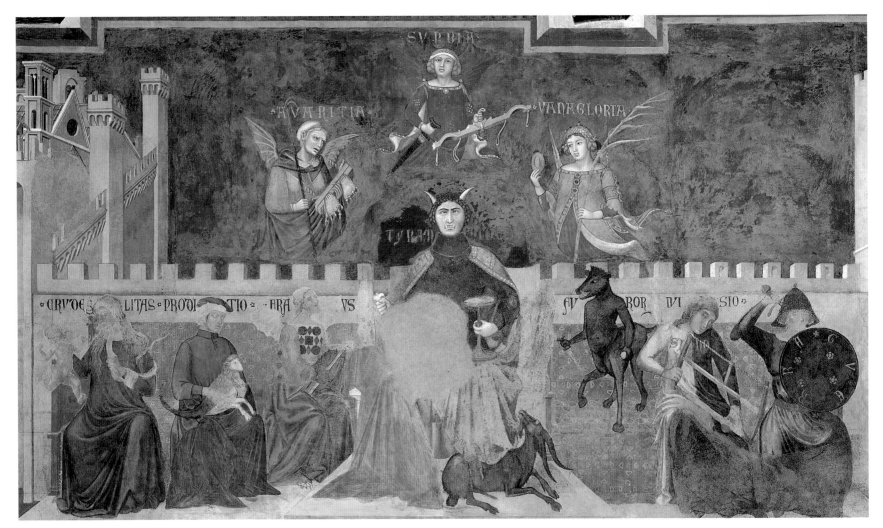

detail, The Court of Tyranny

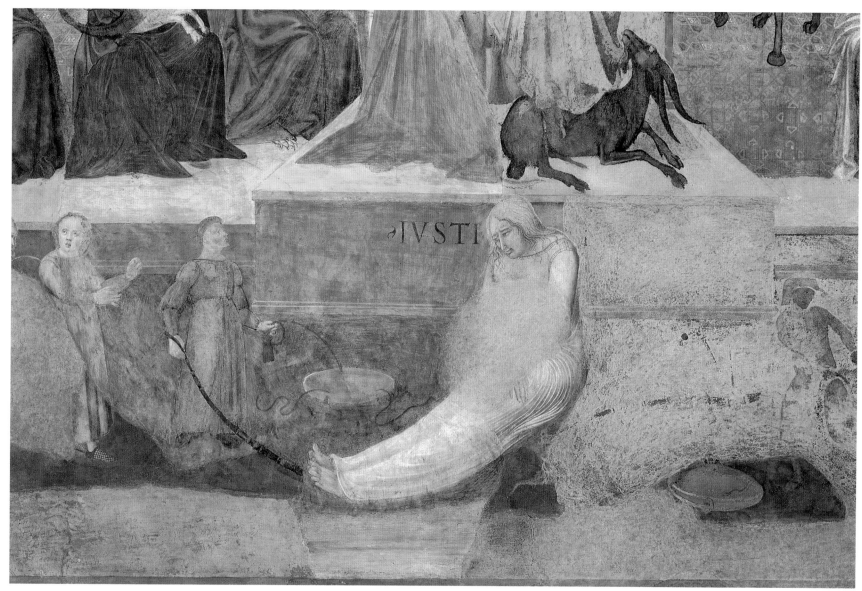

detail, The Court of Tyranny, Justice bound

North wall, "The Virtues of Good Government"

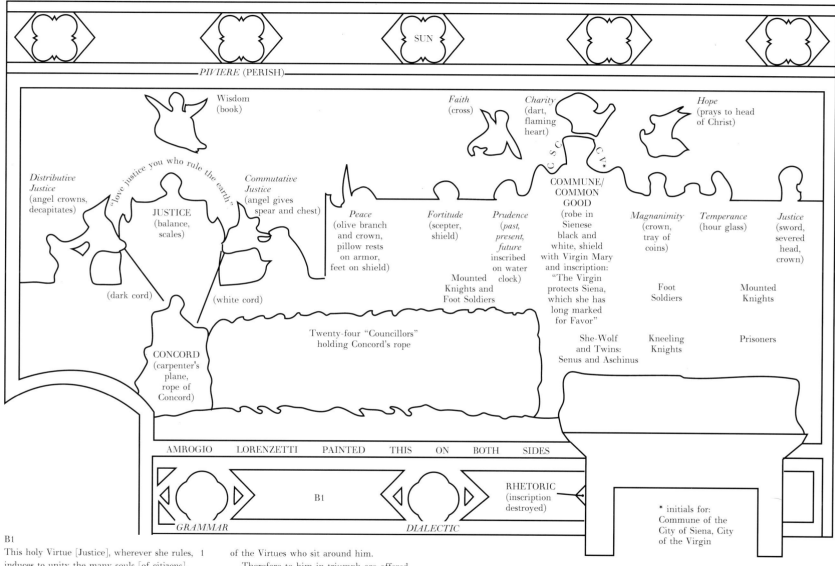

SUN

PIVIERE (PERISH)

Wisdom
(book)

Faith
(cross)

Charity
(dart,
flaming
heart)

Hope
(prays to head
of Christ)

C. S. C. C. V.*

Distributive
Justice
(angel crowns,
decapitates)

"love justice you who rule the earth"

Commutative
Justice
(angel gives
spear and chest)

COMMUNE/
COMMON
GOOD
(robe in
Sienese
black and
white, shield
with Virgin Mary
and inscription:
"The Virgin
protects Siena,
which she has
long marked
for Favor"

JUSTICE
(balance,
scales)

Peace
(olive branch
and crown,
pillow rests
on armor,
feet on shield)

Fortitude
(scepter,
shield)

Prudence
(*past,
present,
future*
inscribed
on water
clock)

Magnanimity
(crown,
tray of
coins)

Temperance
(hour glass)

Justice
(sword,
severed
head,
crown)

(dark cord)

(white cord)

Mounted
Knights and
Foot Soldiers

Foot
Soldiers

Mounted
Knights

CONCORD
(carpenter's
plane,
rope of
Concord)

Twenty-four "Councillors"
holding Concord's rope

She-Wolf
and Twins:
Senus and Aschinus

Kneeling
Knights

Prisoners

AMROGIO LORENZETTI PAINTED THIS ON BOTH SIDES

B1

GRAMMAR

DIALECTIC

RHETORIC
(inscription
destroyed)

* initials for:
Commune of the
City of Siena, City
of the Virgin

B1

This holy Virtue [Justice], wherever she rules, 1
induces to unity the many souls [of citizens],
and they, gathered together for such a purpose,
make the Common Good their Lord;
and he, in order to govern his state, chooses 5
never to turn his eyes
from the resplendent faces

of the Virtues who sit around him.
 Therefore to him in triumph are offered
taxes, tributes, and lordship of towns; 10
therefore, without war,
every civic result duly follows—
useful, necessary, and pleasurable.

See pages 99–101 for additional information and notes on the inscriptions.

Wisdom, Justice, and Concord

This ensemble of image and inscription—texts with pictures and an icon with words—is devoted to the central theme of the frescoes: justice and how to achieve it. The composition is arranged from top to bottom like a four-part analysis or argument: (1) The high virtue of Wisdom instructs (the book) and equips (a quotation from the *Book of Wisdom*, "love justice you who rule the earth," serves as the arms of the scales of Justice); (2) Justice "distributes" and "commutes" rewards and punishments so as to convey the cords that Concord braids together to the first in a procession of twenty-four men; (3) the intertwined cord is held by these citizens, then rises up to the wrist of the figure presiding amid the virtues and over a crowd of soldiers and supplicants on the right side of the picture; (4) the "holy virtue" of Justice reigns, explains the inscription in the frame beneath, where citizens unite to make the Common Good their lord and where he observes the "splendor" of the virtues so that "every civic result duly follows."

The thought here is both eclectic and orderly, though hardly as philosophically sophisticated as modern scholars have supposed. For example, the highly technical distinction between distributive and commutative justice in Aristotle and his most important medieval expositor, St. Thomas Aquinas, is reduced to the simple proposition that justice remedies inequalities by punishing the wicked, crowning the good, and mediating exchanges of goods. (Lorenzetti represented these goods by what seem to be a metalworker's spear in the hand of the kneeling figure on the left and possibly a weaver's distaff or torch in his right hand. The kneeling figure in green on the right side holds a weaver's bale of cloth.) Thus, the most "Thomistic-Aristotelian" passage in the frescoes fails to go beyond the sturdy oversimplifications of Ser Brunetto Latini in *The Great Treasure*, book 2, chapter 38. The pretense that subtle scholastic learning was quite at home in a republic of merchants was just that—a pretense. In any case, the political philosophy of the frescoes was consistent with the language of official documents used by the government.

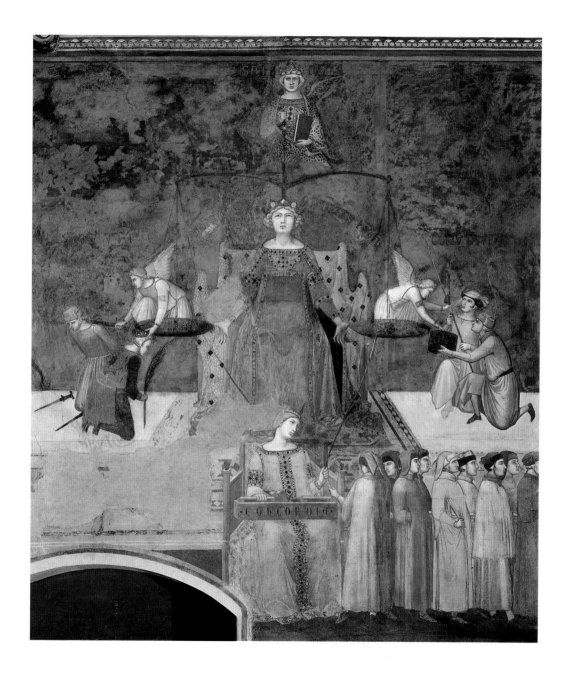

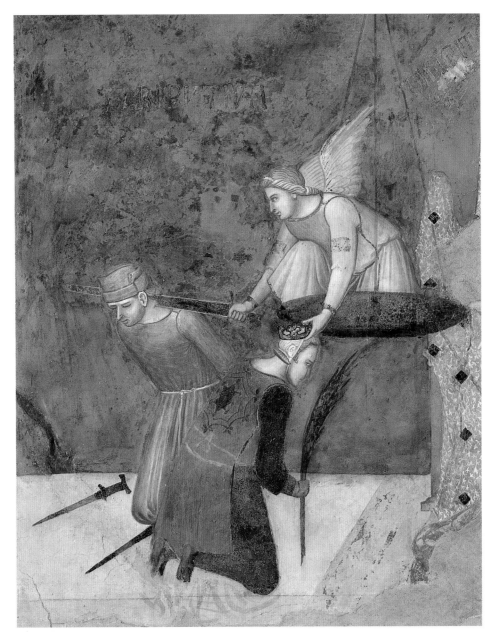

detail, Distributive Justice

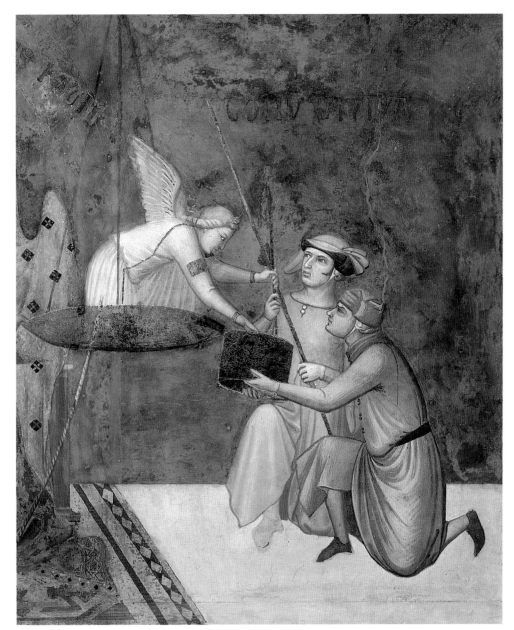

detail, Commutative Justice

The Court of the Common Good

Like the adjacent vices, the virtues on the north ‘wall are familiar but not wholly conventional. Faith, Charity, and Hope are the "theological virtues"—the only explicitly Christian reference in these self-consciously secular frescoes. The seated virtues are variations on the "cardinal virtues" enumerated and illustrated in classical and medieval texts, including again Ser Brunetto Latini's *Great Treasure*. The stupendous central figure is patriarchal, regal, magisterial, and saintly at the same time—a brilliant invention but also strikingly similar to a personification of the Commune sculpted some years before in the nearby town of Arezzo (fig. 11).

The authoritative connotations of the figure are claimed for Siena by its robe (the black and white of the Sienese coat of arms), its regalia (the Virgin Mary, patron saint of the city, on the shield), and the accompanying inscriptions. This is evidently the Common Good, chosen to rule according to the text below, but bound to the concord reached among citizens by the cord around its right wrist.

The composition is clearly designed to outmatch that of the vices. Not only do the virtues have the central wall to themselves, they outnumber the vices, and they have a much more numerous, orderly, and apparently willing company of followers at their feet. These include Ambrogio Lorenzetti, whose "signature" below enrolls him, in effect, among the devotees of the virtues.

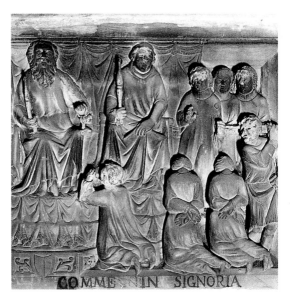

Figure 11: Allegory of Good Government, detail, Monument to Vescovo Guido Tarlati, Cathedral, Arezzo.

58

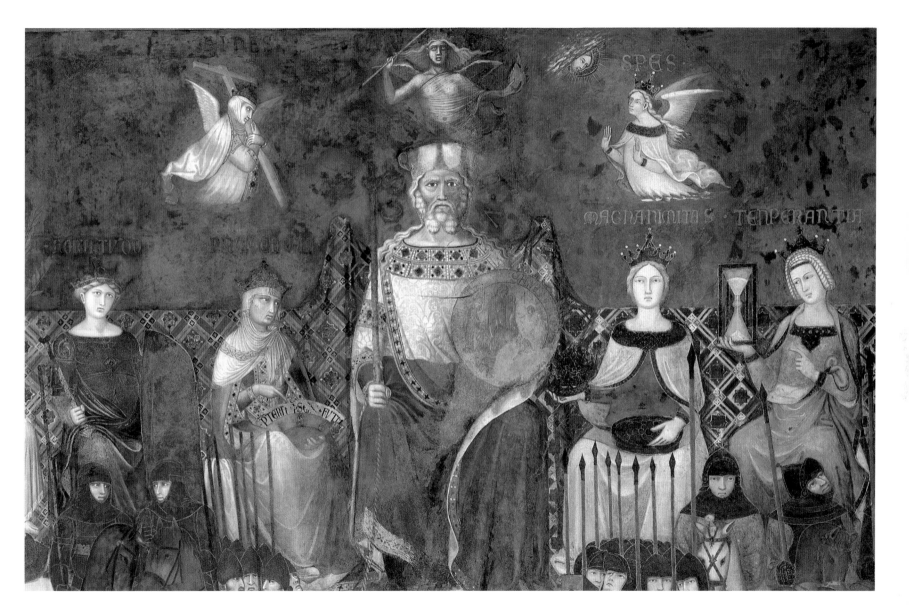

The Virtues: Peace, Fortitude, and Prudence

Like Lorenzetti's crowned queens (or the Statue of Liberty), virtues are nearly always personified as women in Western art. The standard explanation is surely too pedantic: that nouns for abstract concepts are grammatically feminine in Latin. A more satisfying account might begin with social functions and ideology. As mothers and spouses in alliance-making among men, women are indispensable even to the most male-dominated social and political systems. Through a familiar and convenient set of mystifications, this crucial role has traditionally been acknowledged by associating women with "higher values," even as they are excluded from "real" political life. In effect, the bonding of men through their wives, sisters, and daughters is elevated into a community of virtue(s). A fraternity of republican citizens lacking a real court would be particularly inclined to see itself as Lorenzetti shows it: looking up to a fictive court of women representing the principles supposedly uniting and ruling over it.

In any case, the painter could have drawn on any number of medieval literary and pictorial models. The reclining figure of Peace, however, was probably modeled after an ancient coin or relief. The olive branch and crown, the armor underneath her, the shield beneath her feet, the flowing robe were more or less conventional attributes in Roman art. Located at the center of the north wall, radiant, the contours of her body suggestively veiled, she is as spectacularly at peace as the angular, slightly wizened and shrouded figure of Prudence, at the far right of this detail, is prudent.

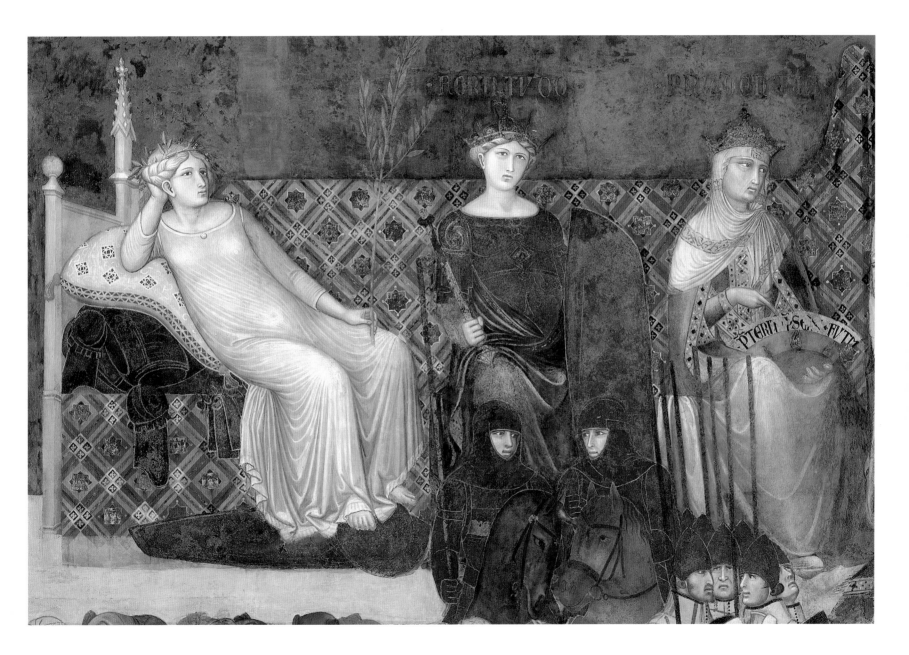

The Virtues: Magnanimity, Temperance, and Justice

Classifying the virtues was an intellectual exercise in classical and medieval literature. Experts would have known that some authorities treated Magnanimity as a branch of Fortitude. Some viewers would have appreciated the passive-active pairings coded into Lorenzetti's arrangement of the virtues. He flanked the "passive" virtue of Temperance with the "active" virtues of Magnanimity and Justice, the precise reverse of the "passive" flanking of Fortitude by Peace and Prudence (pp. 60–61); reading from left to right, passive and active virtues alternate with one another. The gold labels reinforce the diagrammatic effect and literalness of the scheme. Quite apart from any particular message, this iconographical lesson told anyone who cared to know (or to doubt) that republican Siena was devoted to virtue, high culture, and symbolic capital as well as real money.

Note yet another pictorial variation on the theme of Justice. In this second personification of the virtue on the north wall (on the far right of the detail opposite), the crown of just rewards in her lap is overwhelmed by the sword and severed head of her revenge. In keeping with the sexual politics of the virtues Justice and Peace at the other end of the bench (see p. 61) are paradigms of the "eternally feminine," the one an Amazon and the other a Venus (or "Eve," as Lorenzetti painted a similar figure type in a nearly contemporary *Virgin in Majesty* at San Galgano, a Gothic monastery near Siena).

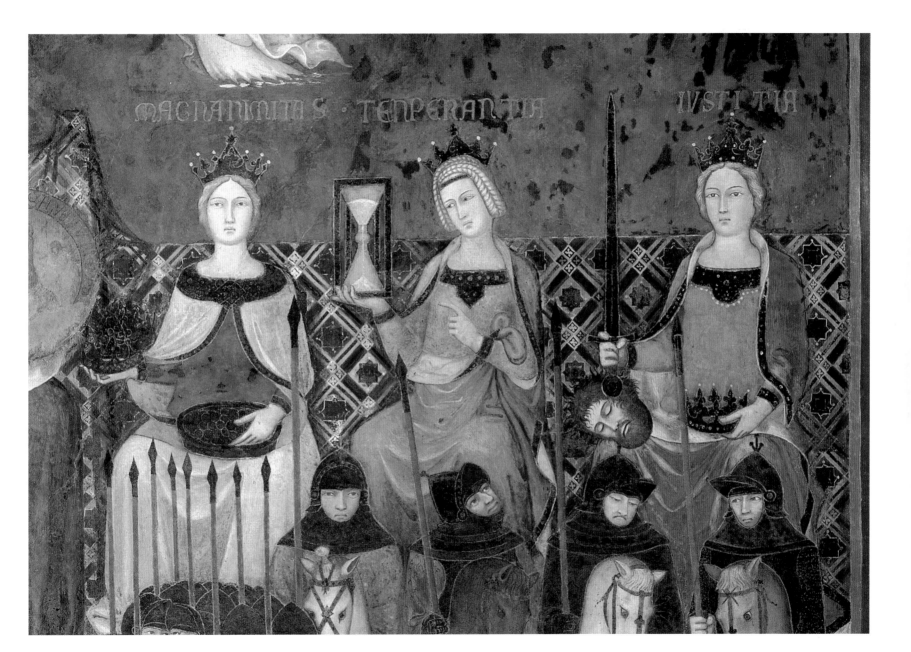

Citizens in Concord

This line of twenty-four citizens is a portrait of civic solidarity and an elaborate pun. The number suggests that they may commemorate (in good republican fashion) the "Founding Fathers," a council of twenty-four that preceded the Nine by some decades. It has also been claimed that the first six figures with fur caps include the chief executive officials and magistrates, the *podestà*, and the Captain of the People, and that the Nine follow, accompanied by the members of other smaller councils. The punning begins on the west wall with the inscription: "where Justice is bound,

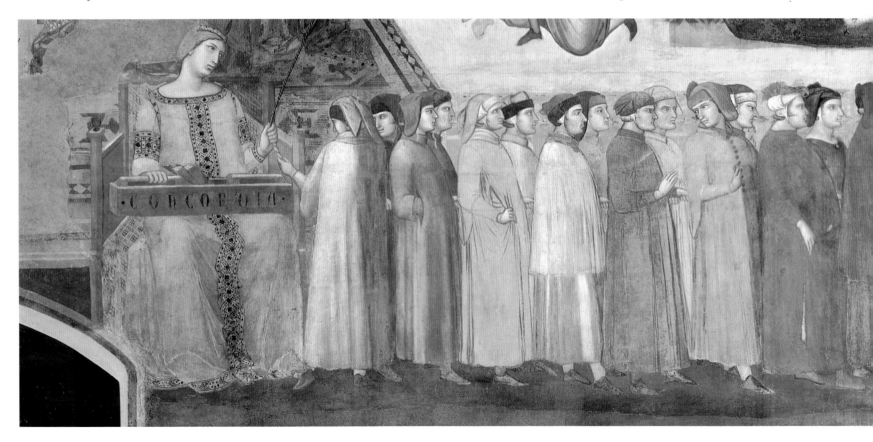

no one is ever in accord for the Common Good, nor pulls the cord straight." Here the twenty-four *do* pull the cord woven by Concord straight. The inscription beneath says that under Justice citizens are "induced" to unity with the Common Good, their lord; the loop of the cord around the wrist of the pictorial counterpart clearly indicates, however, that they are also his lord. The idea is at least as old as Cicero and St. Augustine and as conventional as medieval paraphrases, including a rhyme in the encyclopedic dream poem *The Little Treasure*, by (once again) Ser Brunetto Latini: "But all in common / Should pull a rope / Of Peace and good deeds, / Because there is no escaping for / A city broken by faction." The Sienese would have seen the moral acted out in public works projects to straighten and beautify the streets, as the documents say, *ad cordam* or *a dritta corda*—that is, along the straight line of a surveyor's cord.

"Censi, tributi, e signorie": Offerings to the Common Good

Virtue was not its own reward in the Italian city-republics. According to the inscription in the north-wall plaque, "taxes, tributes, and lordships," with every "useful, necessary, and pleasurable" result, are peacefully offered for the common good in a just and virtuous state. The heavily armed guards and bound and hooded prisoners of the detail on page 67 tell a rather different tale than the inscription—and doubtless a more realistic one. Since Siena could not claim the prestige of having actually been founded by the ancient Romans, the Sienese appropriated it for themselves: Lorenzetti shows (p. 66) the Sienese Romulus and Remus—"Aschinus" and "Senus"—being suckled by the shewolf as offerings rain in on the republic.

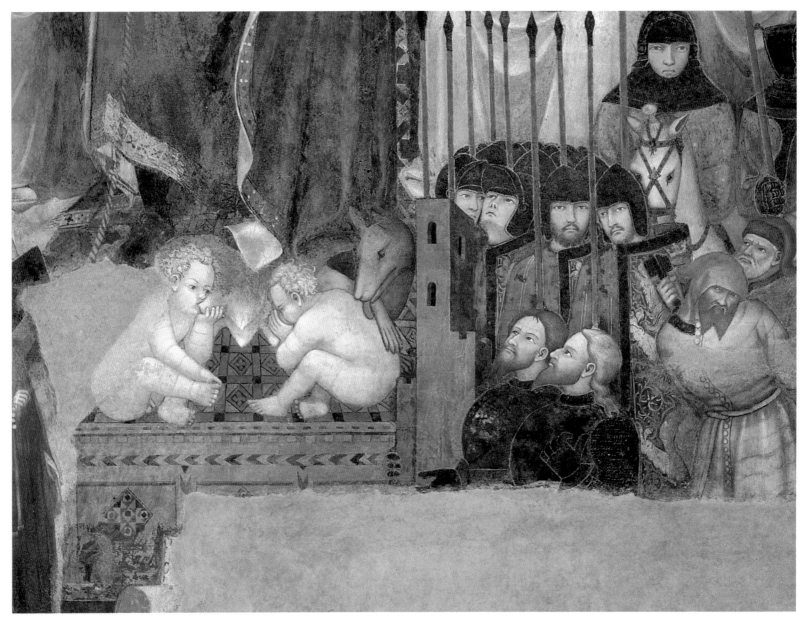

detail, Offerings to the Common Good

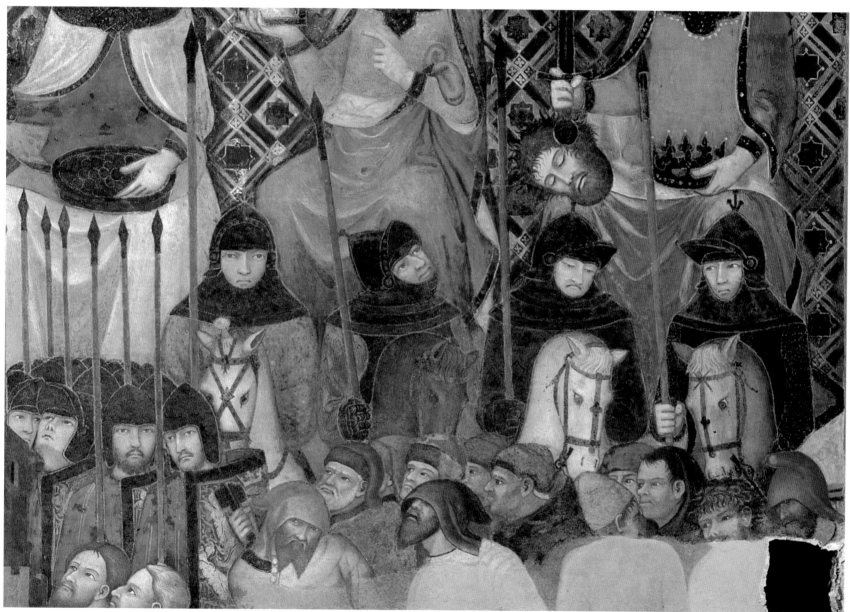

detail, Offerings to the Common Good

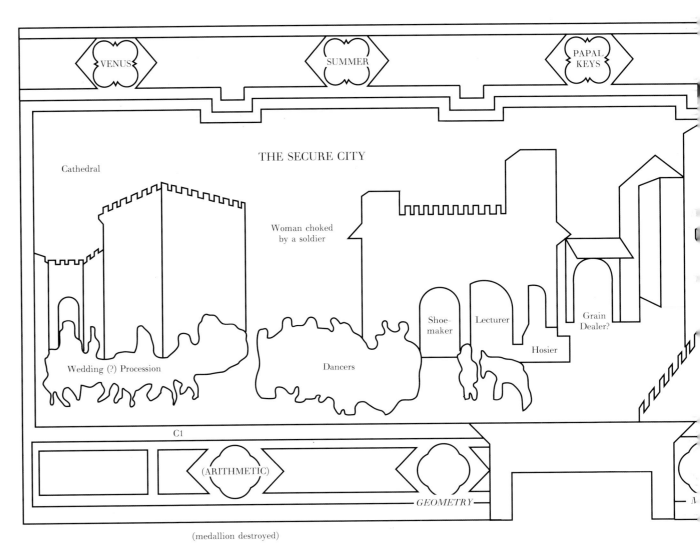

C1

Turn your eyes to behold her, 1
you who are governing, who is portrayed here
 [Justice],
crowned on account of her excellence,
who always renders to everyone his due.
Look how many goods derive from her 5
and how sweet and peaceful is that life
of the city where is preserved
this virtue who outshines any other.
 She guards and defends
those who honor her, and nourishes and feeds
 them. 10
From her light is born [both]
Requiting those who do good
and giving due punishment to the wicked.

See pages 99–101 for additional information
and notes on the inscriptions.

VENUS

SUMMER

PAPAL KEYS

THE SECURE CITY

Cathedral

Woman choked
by a soldier

Shoe-maker

Lecturer

Grain
Dealer?

Hosier

Wedding (?) Procession

Dancers

C1

(ARITHMETIC)

GEOMETRY

(medallion destroyed)

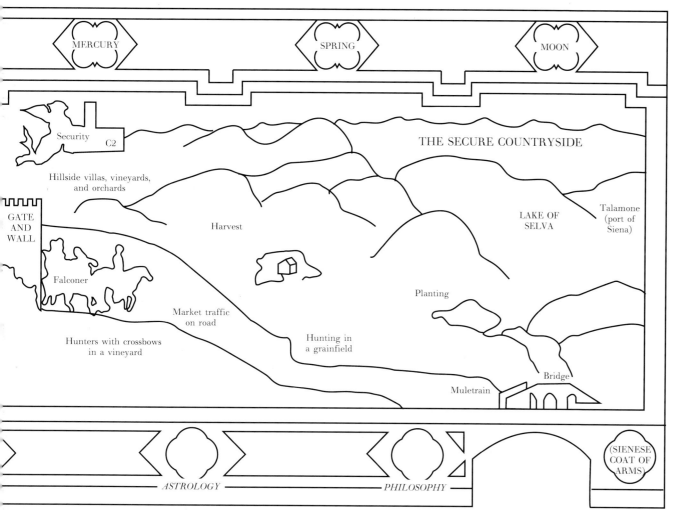

Security C2

THE SECURE COUNTRYSIDE

Hillside villas, vineyards,
and orchards

GATE
AND
WALL

Harvest

LAKE OF
SELVA

Talamone
(port of
Siena)

Falconer

Planting

Market traffic
on road

Hunters with crossbows
in a vineyard

Hunting in
a grainfield

Bridge

Muletrain

C2
Without fear every man may travel freely 1
and each may till and sow,
so long as this commune
shall maintain this lady [Justice]* sovereign,
for she has stripped the wicked of all power. 5

Securitas (Security)

This figure is the opposite number of the harpy of Fear (pp. 42-43) on the west wall. A luminous contrast to the darkness and tattered frenzy of her counterpart, her rounded body is exposed and calmly upright. More of a classical *Winged Victory* than a Christian angel, she hovers over an earthly paradise where, as her scroll proclaims, everyone may freely walk, work, and sow because Justice (or Security herself) reigns. Here again the picture and inscription capture the sentiments of the citizen-poet and former member of the Nine Bindo Bonichi (see p. 42): "*Giustizia fa la gente | Ciascun pascer suo campo*" ("Justice lets each one among the people feed on his own field"). The gallows in her left hand is a sign that Security is no squeamish utopian; as Bonichi puts it, the just magistrate will need to correct and educate, will not refrain "from meting out punishment to anyone who is at fault out of vice; though he may not wish this, men often remain dutiful out of fear" ("*Et qual per vizio pecca, dando pena | Benche non sia di vena | Sta per paura hom sovente leale*"). Patrolling the fresco's city and country halves, Security is the goddess of the panorama—harmonious, balanced, abundant—that is represented beneath as a material reward of civic virtue.

Note the trademark she-wolf and suckling twins of Siena to the left of Security's left toe and above the gate, where they served to identify the town, mark boundaries, and (so we can imagine) ward off enemies as powerful totems. The background landscape shows the classic central Italian mix of grain fields, vines, olive trees, and villas owned by the urban elite.

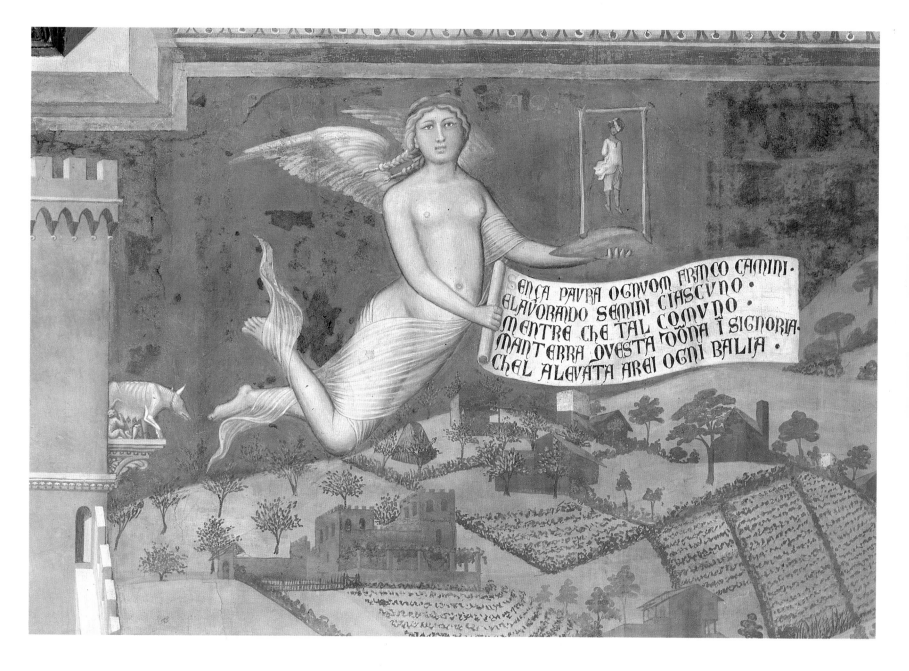

SENÇA PAVRA OGNVOM FRANCO CAMINI·
ELAVORANDO SEMINI CIASCVNO·
MENTRE CHE TAL COMVNO·
MANTERRA QVESTA DONNA Ī SIGNORIA·
CHEL ALEVATA AREI OGNI BALIA·

Singing and Dancing in the Streets of the Ideal Republic

In the *real* town dancing in the streets was forbidden by law out of fear of "inappropriate" extravagance or public disturbance. In the painted square the dancers presumably celebrate the joys of harmonious republican living. The figures dwarf the workaday scenes around them and recall representations of Justice, Concord, and Good Health in medieval literature and art. The comparative examples below (fig. 12; see also fig. 15) are from the illustrations for a medieval health manual translated from Arabic, which circulated widely in the fourteenth century, and from the throne on which Giotto's personification of Justice sits in the Scrovegni Chapel at Padua. Lorenzetti's figures, like Giotto's, dance to a tambourine; like the dancers in fig. 12, they are doing a circle dance while one of them sings. Note that both Giotto and Lorenzetti use the Falconer motif: compare p. 82, fig. 16.

Figure 12: *The Usefulness of Dancing: Joy and Accord. Tacuinum Sanitatis,* University Library of Liège, fol. 64v.

Figure 13: Giotto, *Dancers Celebrating Justice,* ca. 1306, Scrovegni Chapel, Padua.

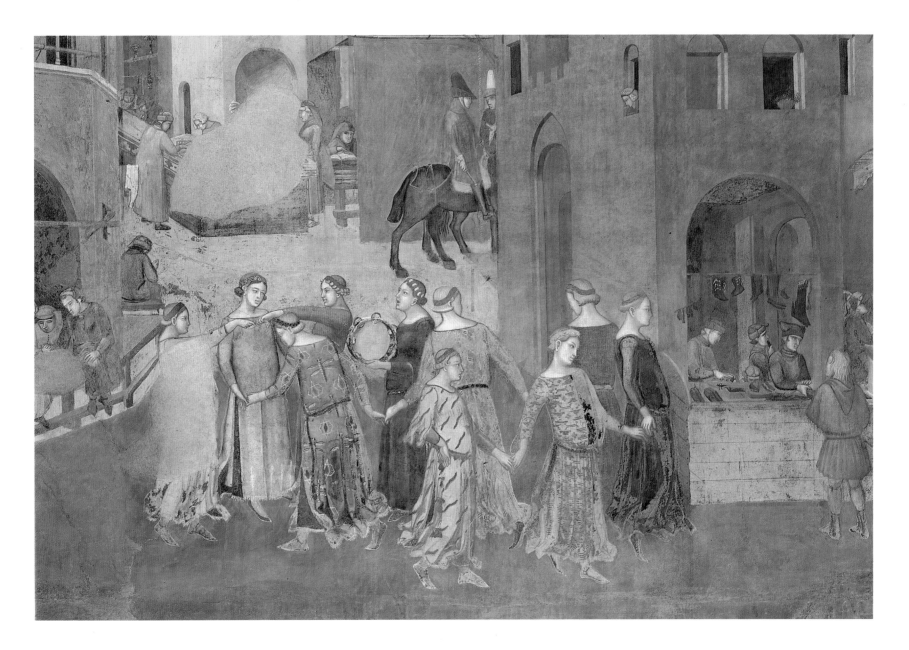

A Wedding Procession (?)

In the sermons he preached before the Palazzo Pubblico in 1427, San Bernardino of Siena cites Lorenzetti's frescoes for lessons on the joys and sorrows of civic life. Describing scenes in the Good City "for the sake of [which] men live in peace and harmony with one another," he refers to merchants buying and selling, dancing, houses being repaired, workers in the fields, riders on horseback, and a wedding procession—evidently the detail opposite. A bride on a white mount, an entourage of male relatives, the reception at the bridegroom's house? This would fit the culminating ceremony in the hard bargaining and symbolic exchanges of marriage in well-to-do urban families. As usual, though, the scene prompting anecdotes about everyday life also has a programmatic place and function in the overall picture. In this case, the detail suits the astrological sign in the frame directly above it ("Venus in the House of Taurus") and elaborates on the dancers' harmony and concord to the right of the procession (see previous page). The regal bearing of the crowned lady amidst the workaday activities of the square suggests a social peace longed for but seldom, if ever, achieved in the Italian city-states. We are also shown that citizens had time to enjoy themselves—the men on the far right are playing a board game in what may be a tavern.

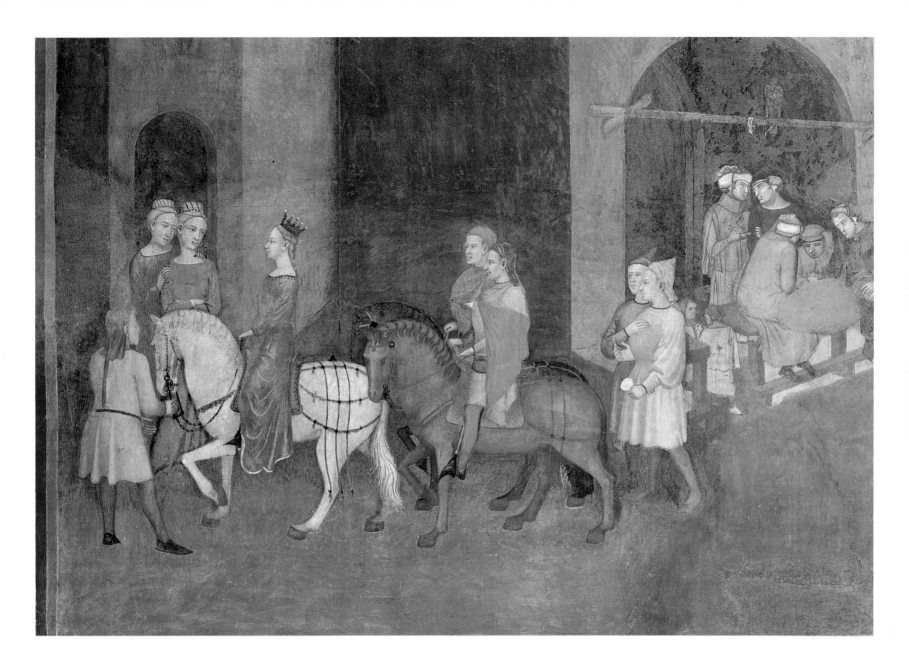

The Republican Dynamo: Crafts, Professions, Trades

The details on the following pages are part inventory, part advertisement, part testimony to the scope of the Nine's authority. From the grain and livestock market, craftsmens' shops, and the lecture hall to builders on a scaffold, the scenes are full of realistic particulars arrayed to persuade the viewer that this utopia, in all senses, *works*. Here we see the industrious people of republican ideology, intent on their own tasks but linked through the marketplace and membership in the community. What we do not see are the conflicts, failures, and elaborate policing measures documented in the surviving archival records for the very year in which Lorenzetti finished his work. Much of the "naturalism" of this beguiling pictorial fiction derives from a genre of manuscript illustrations such as those below.

Figure 14: Grain dealer, *Libro del Biadaiolo*, ca. 1320–35, Biblioteca Medicea Laurenziana, Florence, Ms Tempi 3, fol. 2r.

Figure 15: Shopkeeper, *Tacuinum Sanitatis in Medicina*, Oesterreichisches Nationalbibliothek, Vienna, Codex Vindobonensis, n.s. 2644, fol. 92.

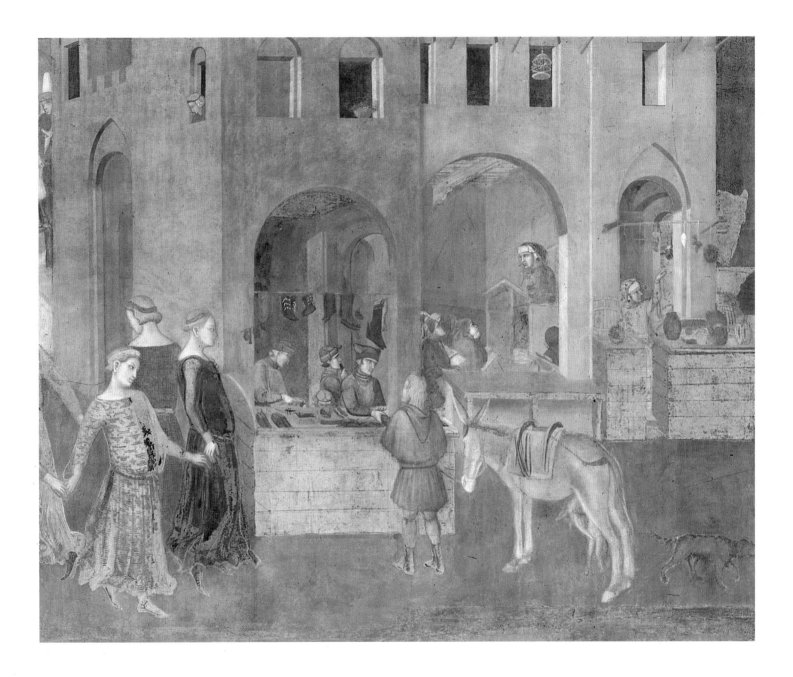

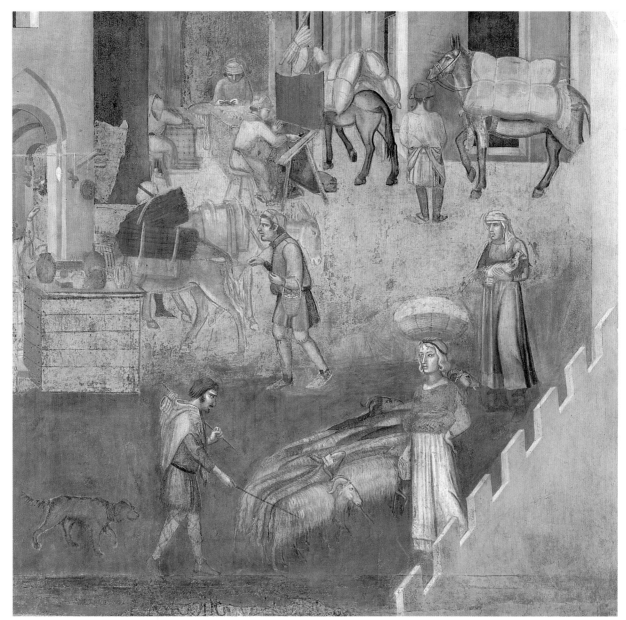

detail, provisions for the Good City

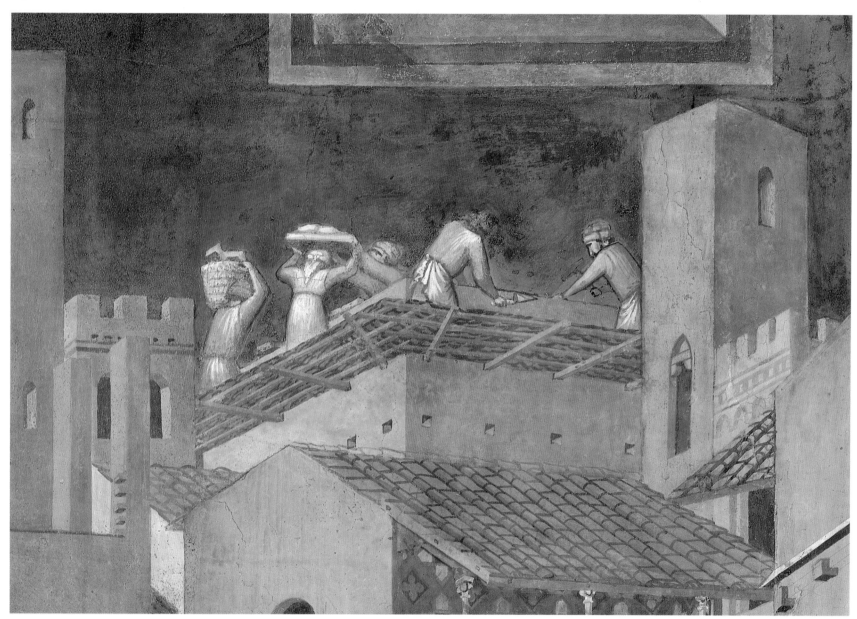

detail, builders at work—the Good City expands

Cityscape

The view of real or imaginary town architecture was a common genre in late-medieval painting. Local pride was one motive—Italians still refer to civic patriotism as *campanilismo*, that is, the view from one's own campanile, or bell tower. The architectural view could be a kind of municipal signature and survey; for the artist it was a challenge to demonstrate skill in handling light, space, and mass. Since St. Augustine's prophetic rewriting of history as a tale of two cities, heavenly and earthly, early in the fifth century, the City of God or a New Jerusalem, was envisioned as a model of perfection, often in the guise of one's own town.

Lorenzetti gives his cityscape both the generic look of a fourteenth-century Italian town and recognizably Sienese features. Battlements and towers were symptomatic of the conflicts of powerful families and factions despite the efforts of the government to control them.

Confined within protective walls, the town core tended to be mazelike with overhanging additions and balconies to make space; social classes and activities were mixed, with little of the differentiation and specialization typical of modern cities. The republican government took great pains to integrate planning and building activities and to enhance the appearance of the city. The steeply rising profile of the buildings in the detail opposite suggests a hill town, which the black-and-white tower to the far left (see plate 5, p. 32) and the she-wolf to the right (see p. 71) identify as Siena. The pointed windows inset within arches of the same shape and divided by white columns of stone is a distinctive Sienese detail, as is the predominant reddish-brown color, presumably to indicate brickwork. These details were already mandated by Siena's model urban planning legislation in the thirteenth century.

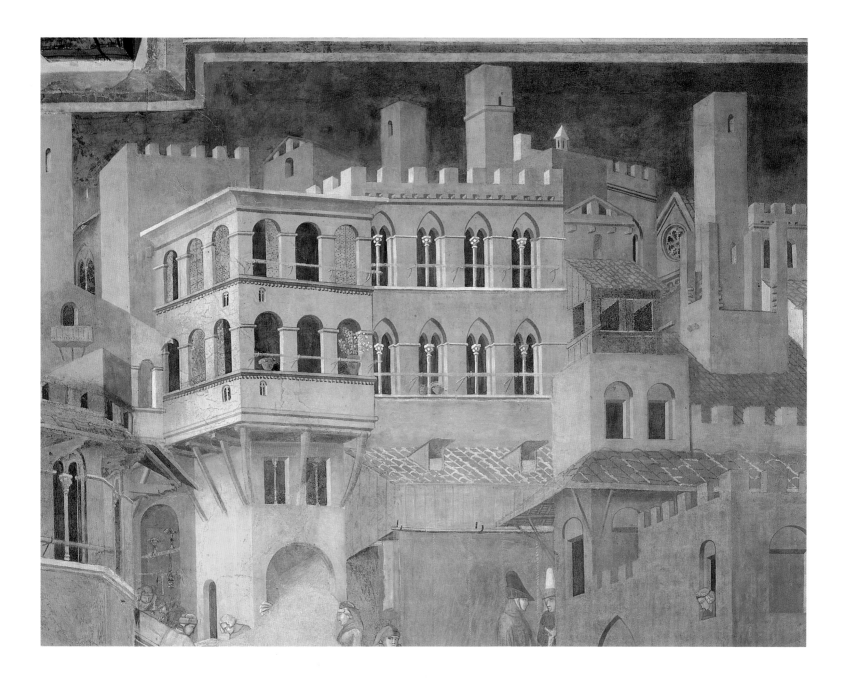

Travelers on the Busy Road of the Secure Country

From the olive trees and vineyards near the gate a road winds down and out into the distance of a hilly countryside. Roads, especially the main north-south highway, the Via Francigena (loosely translated, "French Road"), were vital arteries for landlocked Siena and a constant preoccupation of the Nine. The traffic passing easily to and fro suggests, in paint, a harmonious balance between town and country—a proposition whose reality is much debated by modern historians. A sense of social harmony is conveyed too by the mixed crowd of travelers—the elegant hunters, the pig drover, the muleteers transporting sacks of grain, and, near the gate, the only figure in the room who can be identified as a cleric (he seems to be blessing the town with the sign of the cross). Here again this is no candid camera snapshot. For example, a sculpted version of a falconer in precisely the pose painted by Lorenzetti represents the month of December on the fountain in the main square of Perugia, and bringing pigs to market was a common scene for November in illustrated medieval calendars.

Figure 16: Nicola and Giovanni Pisano, *Falconer as the Symbol of December*, ca. 1278, Fontana Maggiore, Perugia.

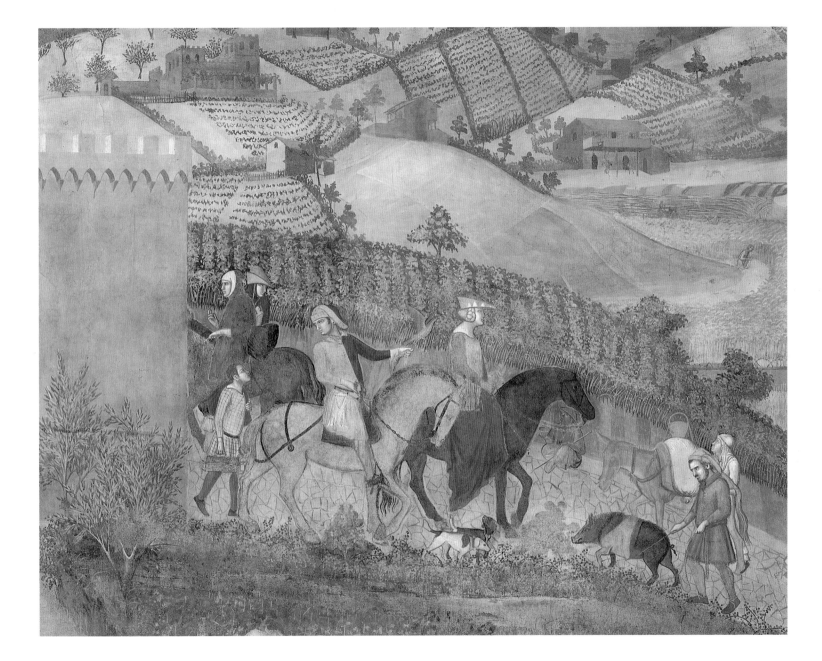

Bountiful Harvests

Even in good years officials of the city republics worried about the food supply. Grain returned three to four seeds for each seed sown, less than one quarter of the modern averages, and that slender margin was at the mercy of scorched earth, military campaigns, banditry, and the weather (the fourteenth century opened with a disastrous cyclical cooling trend). Despite close regulation of the grain market and municipal flour mills by citizens' committees, the years after 1340 when Lorenzetti finished work in the Sala dei Nove saw a series of famines. His never-failing painted harvest was a civic dream. Note here again the resemblance between the motifs in his scene and those in manuscript illuminations.

Figure 17: "The Good Harvest," *Libro del Biadaiolo*, ca. 1320–35, Biblioteca Medicea Laurenziana, Florence, Ms Tempi 3, fol. 6v.

Figure 18: "Harvesting Grain," *Tacuinum Sanitatis in Medicina*, Biblioteca Casanatense, Rome, fol. 87.

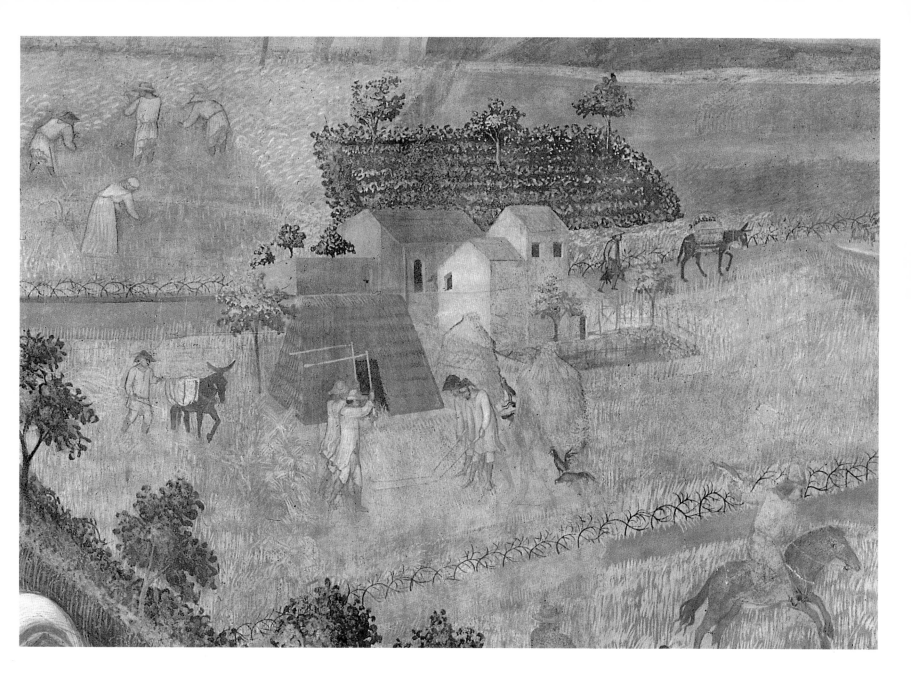

"Water, Wealth/Contentment, Health"

Here too Lorenzetti realizes in paint another fantasy of his fellow citizens. The streams in the hilly upland country around Siena are torrential in winter but likely to run dry in summer—the Sienese still depend on an elaborate system of springs and cisterns for water. Their conviction that an underground river, the Diana, flowed under their town—if only it could be found—was a standing joke and the source of a proverbial saying about foolishly wishful thinking—"to drink the Diana." At the top of this detail we see part of the lake of Selva, swollen beyond recognition in the picture; a rushing stream runs through what is evidently a mill toward the bridge at the bottom, and a fisherman casts his net in the water just above the bridge. On a tributary to the left, a man is watering two mules.

In another pictorial miracle the land that is being harvested nearby in the summer or fall (see p. 85) is being sown here in the spring. The stride of the sower, the stoop of the figure with the hoe, the push of the ploughman, the birds pecking for seeds are infectiously convincing "realistic" touches. The mule train— note the merchants' seals on the bales of goods—and the well-engineered bridge are prominent in the foreground in keeping with the careful attention paid by the Nine and other officials to the transportation network.

The visible cracks in the wall and the abraded surfaces—down to the underdrawing in the case of the foreground animals—make the comparatively good preservation of the larger panorama seem all the more remarkable.

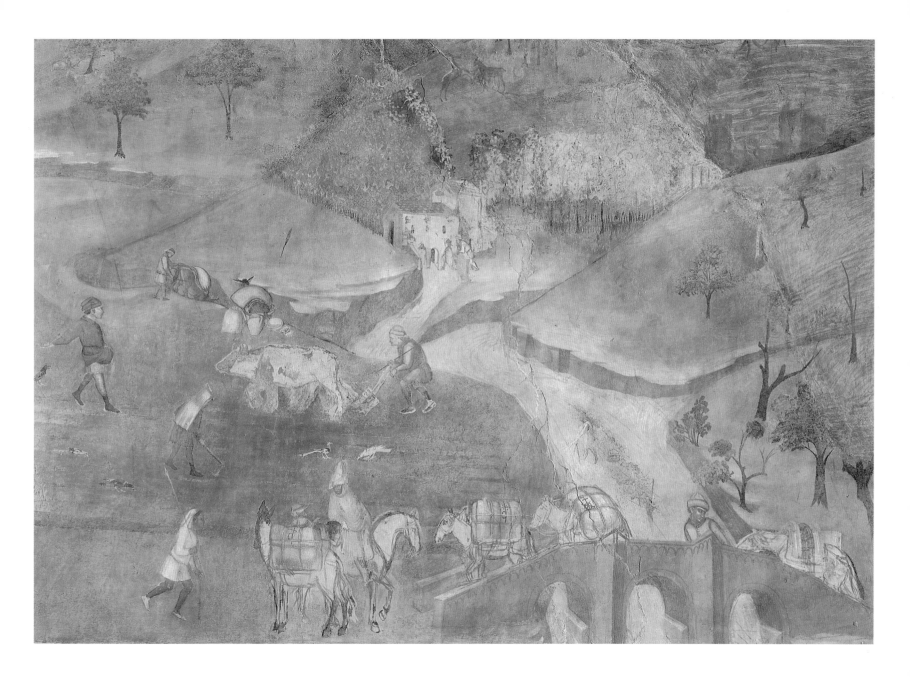

The Medallions

The largest scenes are framed by a decorative border inset with four-lobed (quatrefoil) medallions, each surrounded by a lozenge-shaped plaque—all this in fresco painted to look like stone and mosaic. The medallions above and below are not merely ornamental, but like everything else in the Sala dei Nove designed and arranged with care to convey a republican message. What we see are mostly personifications of schoolbook categories of knowledge classified by medieval authors: the seasons; the planets; the liberal arts; ancient history. References to Christian doctrine are conspicuously lacking. The implication is that good and bad government are influenced by the same natural forces and learned precepts that they simultaneously exemplify. No doubt the viewer was supposed to be impressed that the emblems of so much traditional wisdom line the walls of a council room where workaday political business was conducted. Even making allowances for people's resistance to being preached at or the numbing effect of long-winded speeches, these learned icons were there to be seen and to prompt reflection. The interweaving of the black-and-white shield of the Commune and the rampant lion of the People into the decoration around the upper medallions claims them for the Republic of Siena.

The encyclopedic categories, the medallion format, and the personifications were common in art by Lorenzetti's time. While the genre circulated in manuscript illustrations, sculpture in relief gave it a monumental civic presence in Italy. Particularly important for Lorenzetti were the reliefs of a dynasty of sculptors from Pisa—hence the names Nicola, Giovanni, and Andrea Pisano. They worked on public commissions all over central Italy, including Siena, for a century after 1250. As usual, Lorenzetti borrowed the example and prestige of precedent but adapted or invented where he saw fit.

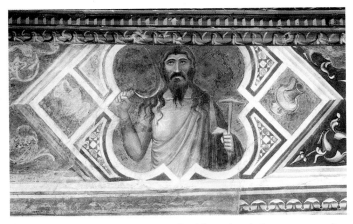

Saturn: the dark planet associated with melancholy, represented here as a clench-fisted antique god.

Autumn: the season of the harvest, with grapes and grain stalks, but also a glowering old man heralding summer's end.

The scenes on the top frieze of the west wall alternate personifications of the planets with the seasons appropriate to the scenes below. The exception is the fourth medallion with the fleurs-de-lys of France. All are half busts, but the poses vary and in the ensemble reinforce the left-to-right direction of the light and the inscriptions. The figure types derive from ancient and medieval sources with more or less freedom of invention and ascribed meaning. Furthermore, there is a contrapuntal opposition between the medallion scenes on the upper borders of the west and east walls: for example, gloomy Saturn faces Venus, and Winter opposes Spring.

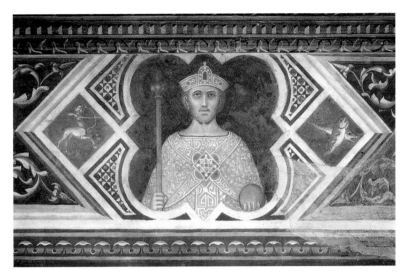

Jupiter: the king of the gods looks sinister; with the scepter and orb of rulership in his hands, certainly no friend of republics.

Arms of France: it is not clear why the fleurs-de-lys are here—as a sign of the threat of monarchy or in retaliation for some particular French offense. Sienese merchants suffered political reprisals in France during the thirteenth century, but the shift from Ghibelline to Guelph alliances in the 1270s put Siena generally among the Italian partisans of the French.

Medallions of the west wall, "The City-State under Tyranny"

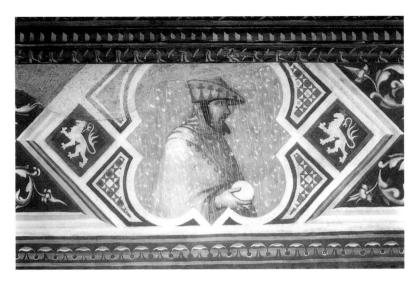

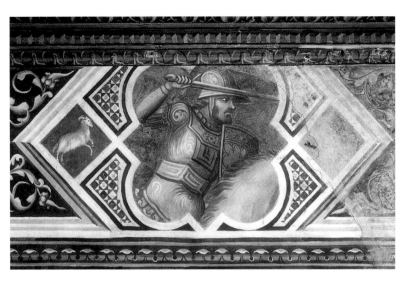

Winter: this figure with a dark crown (another "tyrant"?) underneath a bizarre hat holding a snowball in a storm is one of Lorenzetti's forays in black humor on the west wall.

Mars: a mounted war god, bent on destruction; he brandishes a menacing sword like that of Fear near the other end of the scene beneath.

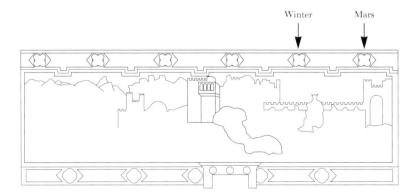

Medallions of the west wall, "The City-State under Tyranny"

This image, so far unidentified, shows a figure stabbing a fallen figure.

The lower medallions on the west wall were devoted to tyrants of antiquity. Only Nero throwing himself on his sword in this medallion remains identifiable.

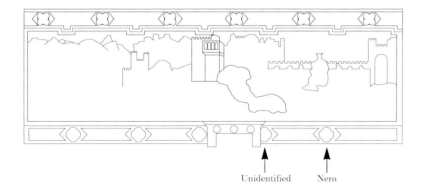

Unidentified Nero

Grammatica and Dialectica

On page 94 we have reproduced the two extant medallions under the mural depicting "The Virtues of Good Government," which represent Grammatica and Dialectica, as well as the inscription between the medallions. These together with Rhetoric, the medallion for which was obliterated by the later door, were the language arts in the medieval school curriculum. They are presumably shown here on the principle that good government is based on civil communication. Moreover, ethics and what we would call political thought had been the province of professional orators—and so of men schooled in grammar, logic, and especially rhetoric—since antiquity. Grammar, pointing to a child to a place in her book, is close to Nicola and Giovanni Pisano's version on the *Fontana Maggiore* in Perugia (fig. 19); Dialectic holds two masks, a profile head of Christ and a satyr's face, presumably implying that while logic can argue both sides of a question, it is compatible with, even necessary for the defense of, Christianity.

Figure 19: Nicola and Giovanni Pisano, *Geometry*, from the *Fontana Maggiore*, marble, compl. 1278, Perugia.

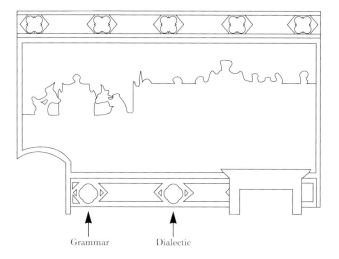

Grammar Dialectic

Medallions of the north wall, "The Virtues of Good Government"

The inscription above the medallions reads: "ambrosius laurentii de senis hic pinxit utrinque," or "Ambrogio Lorenzetti of Siena painted this on both sides." For a transcription and translation of the inscription between the medallions, see B1, pages 100–101 in this volume.

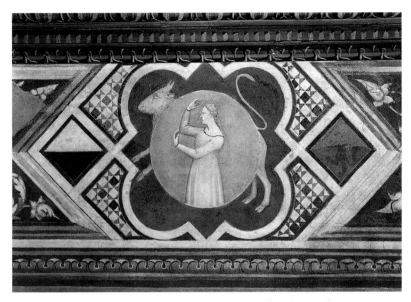

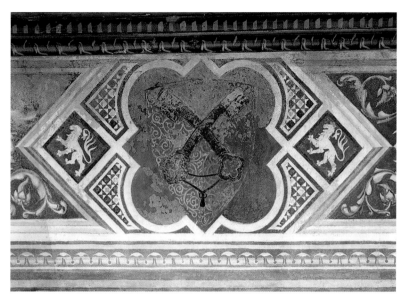

Venus "in the house of Taurus": this astrological constellation is especially apt if the procession below is for marriage (see p. 74). The medallion of Summer, next in order, is effaced beyond recognition.

Papal keys

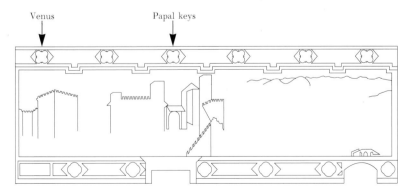

As on the west wall: the planets and the seasons on the top frieze, with the interpolation of a coat of arms—here the keys of St. Peter, the heraldic device of the popes and the insignia of Siena's Guelph allegiance. Here again the medallions derive from ancient and medieval types in manuscripts, mosaic, and relief, and are played off against those opposite. The coordination with the scenes beneath seems to be closer on this side of the room.

Mercury: the messenger of the gods and the planet associated with, among other skilled pursuits, mercantile activity is fittingly placed over the traffic passing to and fro through the gates of the city.

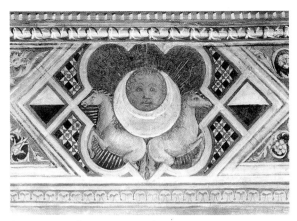

Moon: a bright crescent with streaming rays, the moon is sometimes associated with horses, travel, and water in astrological lore, an association that fits the medallion and the scenes beneath.

Spring: with her luxuriant plant-like hair, scythe, and sheath of grain, and string of fruits or vegetables, this figure is an all-purpose goddess of a fertile countryside and abundant crops as illustrated beneath her.

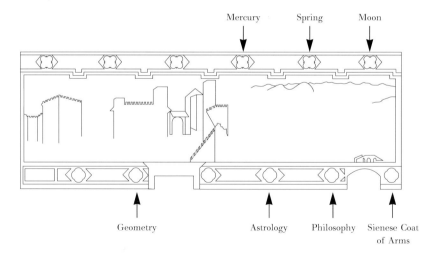

96

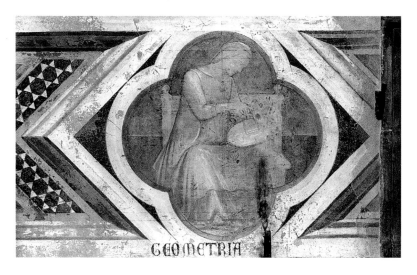

GEOMETRIA

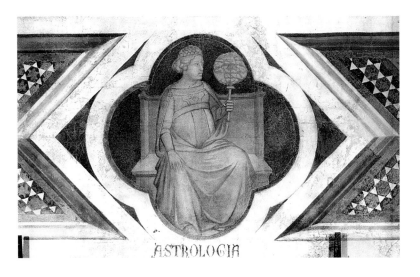

ASTROLOGIA

The Quadrivium, Philosophy, and the Sienese Coat of Arms

Arithmetic, Geometry, Music, and Astrology were the four mathematical branches of the medieval school curriculum. (Music was the science of measure, harmony, proportion, not performing art.) Geometry, her compass poised on a drawing board, closely resembles Nicola and Giovanni Pisano's relief on the *Fontana Maggiore* at Perugia. Astrology holds an armillary sphere rather than an older type of astrolabe. The figures of the quadrivium are oriented toward Philosophy in a queenly frontal pose, her crown, scepter, and volumes of books signifying her place as the culmination of human learning. However, it is the medallion containing the Sienese coat of arms on the other side of the original door that completes the series and in effect anchors the liberal arts in the Sienese republic.

PHILOSOPHIA

INSCRIPTIONS IN THE SALA DEI NOVE

Notes, transcriptions, and translations by
RUGGERO STEFANINI

In the following edition, we start by reproducing the inscriptions, placing in brackets those groups of words that have by now disappeared from the wall because of repainting and alterations but have been preserved in descriptive literature. In A1-B1 and in A3-C2 we keep the paragraphs of the originals but must divide the very long line of A2-C1. We then give the text of every inscription in the standard metric arrangement and in a more readable form (i.e., with graphic, though not linguistic, updating); the English translations and a few notes follow.

A. THE CITY-STATE UNDER TYRANNY
WEST WALL

A1

LADOVE STA LEGATA LA IUSTITIA NESSUNO ALBE(N) COMUNE GIAMAY SACORDA NE TIRA ADRITTA CORDA · P(ER)O CONVIE(N) CHE TIRANNIA SORMONTI · LA QUAL P(ER) ADEMPIR LA SUA NEQUTTIA · NULLO VOLER NE OP(ER)AR DISCORDA · DALLA NATURA LORDA · DE VITII CHE CO(N) LEI SON QUI CO(N)GIONTI · QUESTA CACCIA COLOR CALBEN SON PRONTI · E CHIAMA ASE CIASCUN CAMALE I(N) TENDE · QUESTA SEMPRE DIFENDE · CHI SFORÇA O ROBBA O CHI ODIASSE PACE · UNDE OGNITERRA SUA I(N) CULTA GIACE ·

Là dove sta legata la giustizia, 1
nessuno al ben comun giammai s'accorda
né tira a dritta corda,*
però convien che tirannia sormonti.
La qual, per adempir la sua nequizia, 5
nullo voler né operar discorda
dalla natura lorda
de' vizii che con lei son qui congiónti.
 Questa caccia color ch'al ben son pronti
e chiama a sé ciascun ch'a male intende; 10
questa sempre difende
chi sforza o róbba o chi odiasse pace:
unde ogni terra sua inculta giace.

There, where Justice is bound, 1
no one is ever in accord for the Common Good,
nor pulls the cord [i.e., of civic concord] straight [i.e., with force and full commitment];
therefore, it is fitting that Tyranny prevails.
She,† in order to carry out her iniquity, 5
neither wills nor acts in disaccord
with the filthy nature
of the Vices, who are shown here conjoined with her.
She banishes those who are ready to do good
and calls around herself every evil schemer. 10
She always protects
the assailant, the robber, and those who hate peace,
so that her every land lies waste.

* For the *figura* (pseudo-)*etymologica* referring *Concordia* to *chorda* (cord or rope, musical chord), cf. Cicero, *De republica* 2.69; Isidore of Seville, *Etymologiae* 3.22.6; and Dante, *Paradiso* 26.45–51.
† Stefanini translates the feminine pronouns literally; the androgynous ambiguity of this traditionally male figure contributes, of course, to its sinister effect. [Author's note.]

A2

[.
.] E P(ER) EFFETTO · CHE DOVE E TIRANNIA E GRAN SOSPETTO · GUERRE RAPINE TRADIMENTI EN GANNI · PRENDANSI SIGNORIA SOPRA DI LEI · EPONGASI LA MENTE ELO INTELLETTO · [IN TENER SEMPRE A IUSTICIA SUGGIETTO · CIASCUN P(ER) ISCHIFAR SI SCURI DANNI · ABBATTENDO E TIRANI E C]HI TURBAR LAVUOL SIE P(ER) SUO MERTO · DISCACCIATE DISERTO · IN SIEME CON QUALUNQUE SIA SEGUACIE · FORTIFICANDO LEI P(ER) VOSTRA PACE ·

[. -anni* 1
.] e per effetto
Che dove è tirannia è gran sospetto,
guerre, rapine, tradimenti e 'nganni,
prendansi [prendasi?] signoria sopra di lei[,?]† 5
e pongasi la mente e lo 'ntelletto
in tener sempr'a giustizia suggetto

ciascun, per ischifar sì scuri danni,
 abbattendo e' tiranni;
e chi turbar la vuol sie per suo merto 10
discacciat'e diserto
insieme con qualunque sia seguace,
fortificando lei per vostra pace.

[. 1
.] and for the reason
that, where there is Tyranny, there are great fear,
wars, robberies, treacheries and frauds,
she must be brought down.† 5
And let the mind and understanding be intent
on keeping each [citizen] always subject to Justice,
in order to escape such dark injuries,
 by overthrowing all tyrants.
And whoever wishes to disturb her [Justice], let him be for his unworthiness 10
banished and shunned
together with all his followers, whoever they may be:
thus Justice will be fortified to the advantage of your peace.

*The rhyme word at the end of the first line may have been *malanni* (mishaps, calamities), belonging to the sematic range of *danni, inganni, tiranni.*
†I consider *prendansi* (3d pers. pl.) a mistake and would substitute the required third person singular, which is also paralleled and supported by the following *pongasi.* [Author's note: Alternatively, reading *prendansi*, the passage might be translated "where there is Tyranny, there is great fear; / wars, robberies, treacheries, and frauds / take authority over the city."]

A3

P(ER) VOLERE ELBENPROPIO I(N)QUESTA TERRA ·
SOM(M)ESSE LA GIUSTITIA ATYRANNIA ·
UNDE P(ER) QUESTA VIA ·
NO(N) PASSA ALCUN SE(N)ÇA DUBBIO DIMO(R)TE ·
CHE FUOR SIROBBA E DENTRO DALEPORTE ·

Per voler el ben propio, in questa terra 1
sommess'è la giustizia a tirannia,
unde per questa via
non passa alcun senza dubbio di morte,
ché fuor si róbba e dentro dalle porte. 5

Because each seeks only his own good, in this city 1
Justice is subjected to Tyranny;
Wherefore, along this road
nobody passes without fearing for his life,
since there are robberies outside and inside the city gates. 5

B. THE VIRTUES OF GOOD GOVERNMENT
NORTH WALL

B1

QUESTA SANTA VIRTU LADOVE REGGE · INDUCE ADUNITA LIANIMI
MOLTI · EQUESTI ACCIO RICOLTI · UN BEN COMUN PERLOR SIGNOR SIFANNO
LOQUAL P(ER) GOVERNAR SUO STATO ELEGGE · DINO(N)TENER GIAM(M)A
 GLIOCHI RIVOLTI ·
DALO SPLENDOR DEVOLTI · DELE VIRTU CHETORNO ALLUI SISTANNO ·
P(ER) QUESTO CONTRIUNFO ALLUI SIDANNO · CENSI TRIBUTI ESIGNORIE
DITERRE · PER QUESTO SENÇA GUERRE · SEGUITA POI OGNI CIVILE
EFFETTO · UTILE NECESSARIO EDIDILETTO ·

Questa santa virtù, là dove regge, 1
induce ad unità gli animi molti,
e questi, a ciò ricolti,
un ben comun per lo signor si fanno.
Lo qual, per governar suo stato, elegge 5
di non tener giammà' gli occhi rivolti
dallo splendor de' vólti
delle virtù che torno a lui si stanno.
 Per questo con triunfo a lui si dànno
censi, tributi e signorie di terre; 10
per questo senza guerre
seguita poi ogni civile effetto—
utile, necessario e di diletto.

This holy Virtue [Justice], wherever she rules, 1
induces to unity the many souls [of citizens],
and they, gathered together for such a purpose,
make the Common Good their Lord;
and he, in order to govern his state, chooses 5
never to turn his eyes
from the resplendent faces of the
Virtues who sit around him.

100

Therefore to him in triumph are offered
taxes, tributes and lordship of towns; 10
therefore, without war,
every civic result duly follows—
useful, necessary, and pleasurable.

those who honor her, and nourishes and feeds them. 10
From her light is born [both]
Requiting those who do good
and giving due punishment to the wicked.

C. THE GOOD CITY-REPUBLIC
EAST WALL

C1

VOLGIETE GLIOCCHI ARIMIRAR COSTEI · VOCHE REGGIETE CHE QUI
FIGURATA · E P(ER)SUE CIELLE(N)ÇIA CORONATA · LAQUAL SE(M)PRA
CIASCUN SUO [DRITTO RENDE · GUARDATE QUANTI BEN VENGAN DA LEI ·
ECOME E DOLCE VITA ERIPOSATA · QUELLA] DELA CITTA DUE SERVATA ·
QUESTA VI(R)TU KEPIU DALTRA RISPRE(N)DE · ELLA GUARD(A)E DIFENDE ·
CHILEI ONORA E LOR NUTRICA E PASCIE · DA LA SUO LUCIE NASCIE · EL
MERITAR COLOR COPERAN BENE · E AGLINIQUI DAR DEBITE PENE ·

Volgete gli occhi a rimirar costei, 1
vo' che reggete, ch'è qui figurata
e per su' eccellenzia coronata,
la qual sempr'a ciascun suo dritto rende.
Guardate quanti ben vengan da lei 5
e come è dolce vita e riposata
quella della città du' è servata
questa virtù che più d'altra risprende.
 Ella guard'e difende
chi lei onora e lor nutrica e pasce. 10
Dalla suo luce nasce
el meritar color ch'operan bene
e agli iniqui dar debite pene.

Turn your eyes to behold her, 1
you who are governing, who is portrayed here [Justice],
crowned on account of her excellence,
who always renders to everyone his due.
Look how many goods derive from her 5
and how sweet and peaceful is that life
of the city where is preserved
this virtue who outshines any other.
 She guards and defends

SENÇA PAURA OGNUOM FRANCO CAMINI ·
ELAVORANDO SEMINI CIASCUNO ·
MENTRE CHE TAL COMUNO ·
MANTERRA QUESTA DON(N)A I(N) SIGNORIA ·
CHEL ALEVATA AREI OGNI BALIA. ·

Senza paura ogn'uom franco cammini 1
e lavorando semini ciascuno,
mentre che tal comuno
manterrà questa donna in signoria,
ch' ell'ha levata a' rei ogni balia. 5

Without fear every man may travel freely 1
and each may till and sow,
so long as this commune
shall maintain this lady [Justice]* sovereign,
for she has stripped the wicked of all power. 5

* Stefanini prefers Justice, although "this lady" may also be Security. [Author's note.]

SELECTED BIBLIOGRAPHY

Pietro Bilancioni, ed. *Rime di Bindo Bonichi*. Bologna, 1867.

Eve Borsook, *Ambrogio Lorenzetti*, trans. Piero Bertolucci. Florence: Sadea/Sansoni Editori, 1966. (A brief monograph written by a leading student of Italian fresco painting.)

William M. Bowsky, *A Medieval Italian Commune: Siena under the Nine, 1287-1355*. Berkeley and Los Angeles: University of California Press, 1981. (A masterful academic survey, based largely on archival sources.)

Chiara Frugoni, *A Distant City: Imaqes of Urban Experience in the Medieval World*, trans. William McCuaig. Princeton: Princeton University Press, 1991. (The ideal of the city in medieval art.)

Uta Feldges-Henning, "The Pictorial Programme of the Sala della Pace: A New Interpretation," *Journal of the Warburg and Courtauld Institutes* 35 (1972): 145-62. (Emphasizes the "Mechanical Arts" on the east wall.)

Jack M. Greenstein, "The Vision of Peace: Meaning and Representation in Ambrogio Lorenzetti's Sala della Pace Cityscapes," *Art History* 11 (1988): 492-510. (Offers an ingenious argument that the figure of Peace is the key to the fresco program.)

Bram Kempers, *Painting, Power and Patronage: The Rise of the Professional Artist in Renaissance Italy*, trans. Beverley Jackson. London: Allan Lane, The Penguin Press, 1992. (Emphasizes the patron's role and the social history of how art is made.)

John Larner, *Culture and Society in Italy, 1290-1420*. (New York: Scribner, 1971). (Still the best historian's survey of art, literature, society, and politics for the period.)

Lauro Martines, *Power and Imagination: City-States in Italy*. New York: Alfred Knopf, 1979. (A lively, comprehensive survey.)

George Rowley, *Ambrogio Lorenzetti*, 2 vols. Princeton, N. J.: Princeton University Press, 1958. (An outdated, but basic monograph.)

Nicolai Rubinstein, "Political Ideas in Sienese Art: The Frescoes by Ambrogio Lorenzetti and Taddeo di Bartolo in the Palazzo Pubblico," *Journal of the Warburg and Courtauld Institutes* 21 (1959): 179–207. (Until challenged recently, the standard analysis emphasizing debts to the political ideas of Aristotle and St. Thomas Aquinas.)

Quentin Skinner, "Ambrogio Lorenzetti: The Artist as Political Philosopher," *Proceedings of the British Academy* 72 (1986): 1-56. (A detailed analysis, arguing that the ideas informing the north wall drew upon old-fashioned and practical political theories.)

Randolph Starn and Loren Partridge, *Arts of Power: Three Halls of State in Italy, 1300-1600*. Berkeley and Los Angeles: University of California Press, 1992. (Contrasts "regimes" of politics and art—republican, princely, and "triumphalist"—over three centuries of Italian history.)

GLOSSARY OF FRESCO TERMS

Affresco (from the word for "fresh"; in English, "fresco"). Painting on freshly laid plaster with pigments dissolved in water. As plaster and paint dry together, they become united chemically. Known as "true" fresco (or "buon fresco"), but frequently used in combination with "secco" (see below) details, this technique was in general use for mural painting in Italy from the late thirteenth century on.

Arriccio (literally "rough"). The first layer of plaster spread on the masonry in preparation for painting; the "sinopia" (see below) is executed on this surface. It was purposely left rough so that the top layer (see "intonaco") would adhere to it more firmly.

Cartone (from the word for "heavy paper"; in English, "cartoon"). An enlarged version of the main lines of the final composition done on paper or cloth, sometimes, but not always, equal in size to the area to be painted. The cartoon was used to transfer the design to the wall; it could be divided in several sections for the creation of one large image. The cartoon was laid against the wall over the final layer of fresh plaster, so that outlines of the forms could be either incised with a stylus or transferred by "pouncing" (see "spolvero"). In either case, the outlines were used as guides for the artist to paint. The procedure was in common use by the second half of the fifteenth century, although it had been developed earlier.

Giornata (from the word for "day"). The patch of "intonaco" to be painted "daily," not necessarily in one day. The artist decided in advance the size of the surface he would paint and laid on top of the "arriccio" or rough plaster only the amount of fresh "intonaco" or fine plaster needed for his work. The joinings usually are discernible upon a close examination of the painted surface, and they disclose the order in which the patches were painted because each successive patch slightly overlaps the preceding one.

Intonaco (literally "whitewash," or fine plaster). The final smooth layer of plaster on which painting with colors was carried out. Made from lime, fine sand, and marble dust and laid in sections (see "giornata").

Pounce, pouncing. Fine powder, usually pulverized charcoal, dusted over a stencil to transfer a design to an underlying surface.

Secco (literally "dry"). Painting on plaster that has already dried. The colors are mixed with an adhesive or binder to attach the color to the surface to be painted. The binding medium may be made from various substances, such as tempera. "Tempera" (pigment and animal or vegetable glue) or less often "tempera grassa" (pigment and egg) was commonly used to complete a composition already painted in fresco. Because the pigment and the dry wall surface do not become thoroughly united, as they do in true fresco, mural paintings done in tempera (or "a secco") tend to deteriorate and flake off the walls more rapidly.

Sinopia Originally a red ochre named after Sinope, a town on the Black Sea that was well known for its red pigments. In fresco technique the term was used for the final preparatory drawing on the "arriccio," which was normally executed in red ochre.

Spolvero (from the word for "dust"). An early method (see "cartone") of transferring the artist's drawing onto the "intonaco." After drawings as large as the frescoes were made on paper, their outlines were pricked, and the paper was cut into pieces the size of each day's work. After the day's patch of "intonaco" was laid, the corresponding drawing was placed over it and "dusted" with a cloth sack filled with charcoal powder, some of which passed through the tiny punctured holes to mark the design on the fresh "intonaco."